CRAFTY BIRDS

> **BIRD ART AND CRAFTS FOR MIXED-MEDIA ARTISTS**

Edited by KRISTY CONLIN

NORTH
LIGHT
BOOKS

CINCINNATI, OHIO

›› CONTENTS

Introduction .. 4

› CHAPTER 1: JEWELRY 6

Bird Nest Ring and Earrings 8

His Wings Necklace 16

Broken Heart Necklace 24

Guardian Cuff 28

› CHAPTER 2: COLLAGE BIRDS 34

"Create" Banner 36

Contemplate Bird 44

Collaged Box 48

My Fledgling 54

Royal Bird 60

› CHAPTER 3: MIXED-MEDIA BIRDS 62

Birdcage Memories 64

Bird Feeder 70

Poetry Folio 74

Soul Shine 80

Tweet .. 84

Learning to Soar 92

Bluebird of Happiness Pincushion ... 100

Two Birds on a Branch 110

Cast Object Assemblage 114

About the Contributors 120
About the Books 124
Index 126

For more information about the artists and books featured here, and for access to free wallpapers and more, scan this QR Code with your smartphone, or visit:

CREATEMIXEDMEDIA.COM/CRAFTY-BIRDS

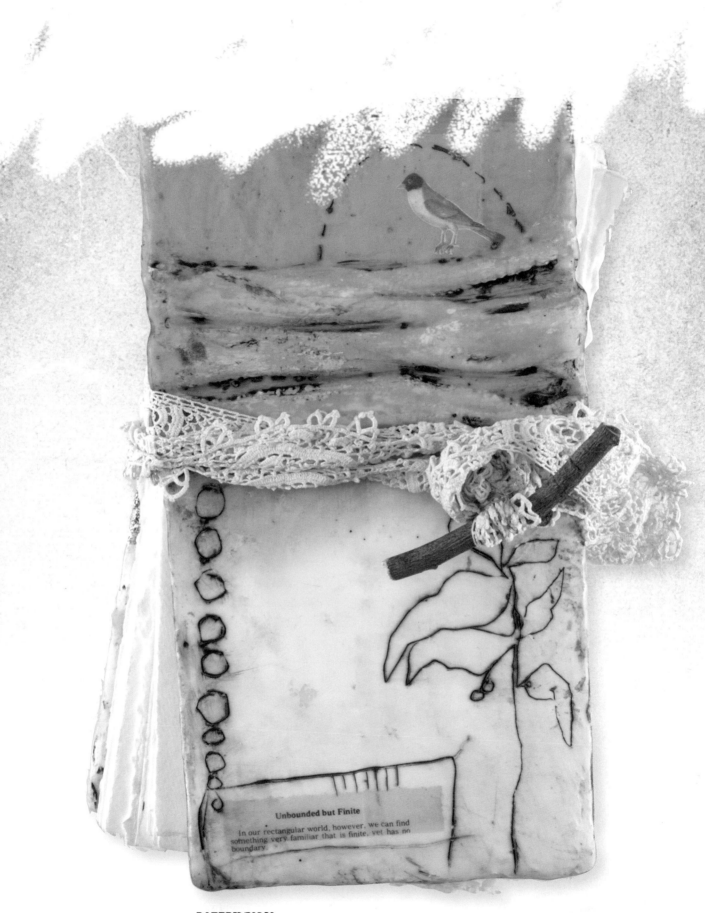

POETRY FOLIO
From PLASTER STUDIO *by Stephanie Lee*

Unbounded but Finite

In our rectangular world, however, we can find
something very familiar that is finite, yet has no
boundary.

» INTRODUCTION «

Bluebirds, hawks, hummingbirds, swallows, doves, peacocks, wrens, crows, swans, robins, larks, magpies, eagles …

From origami paper cranes to the Phoenix rising from the ashes to, well, the Road Runner, birds of every size and stripe have claimed a prominent place in art and popular culture. And let me be the first to admit it—their allure is hard to resist. But how to define that allure? I'm convinced there is no one thing that elevates our feathered friends to cultural icon status—rather, turns out birds have a whole lot going for them.

For example, isn't there a certain grace to these seemingly delicate creatures, many of which put something of a spell over us merely with their song? And then, of course, there's that whole flying thing—soaring above the trees, the clouds, that … freedom that so many of us crave. But I believe that, really, so many of us identify with the *symbolism* attached to birds, to specific birds. Like the swallow. The swallow is considered a symbol of protection and warmth, a representation of home and security. The raven also is steeped in symbolism; he is perceived as magical, a shape-shifter and a forbearer of omens. And the bluebird is a frequent visitor to literature and popular culture as well, usually signifying happiness, modesty and an unassuming confidence.

It's no wonder, then, that with all this meaning, birds have been a common subject for so many of our artists here at North Light, authors whose chosen mediums could not be more varied. And so here is an opportunity to share with you a beautiful collection of projects to experiment with, maybe try something new, maybe to create something special. Marie French's *Broken Heart Necklace* is steeped spirituality and miracle thinking. Susan Tuttle's *My Fledgling* is heartfelt and sentimental. And Jen Osborn's *Bluebird of Happiness Pincushion* is lighthearted and fun.

With just those three projects you'll become a jewelry-making pro, learn mad Adobe Photoshop skills and stitch up a mixed-media masterpiece. But with *Crafty Birds*, you'll also learn about wire-wrapping, plaster casting, collage, assemblage, journal making, soldering, working with encaustics and so much more.

I, for one, am crazy as a loon for the projects assembled here, and I hope you'll enjoy them every bit as much as I do!

~ *Kristy Conlin*

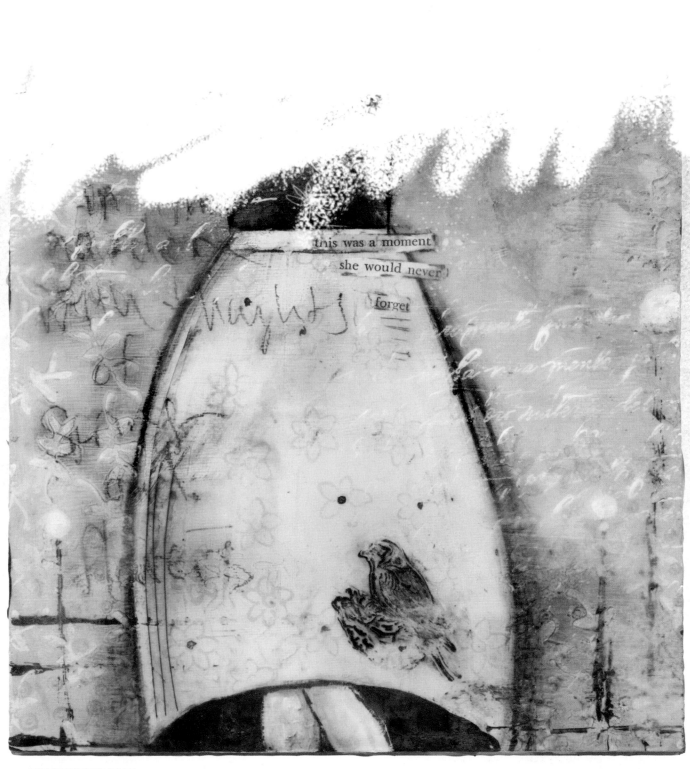

LEARNING TO SOAR
From Taking Flight by Kelly Rae Roberts

5

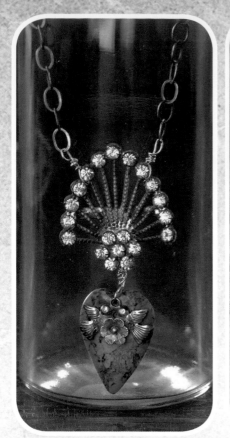

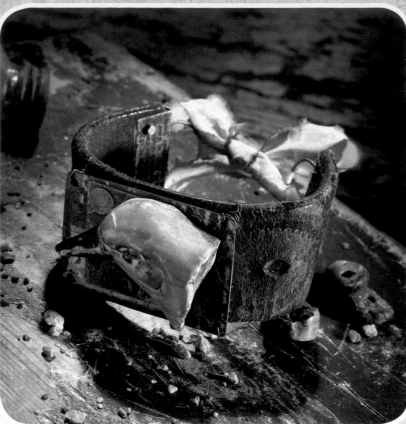

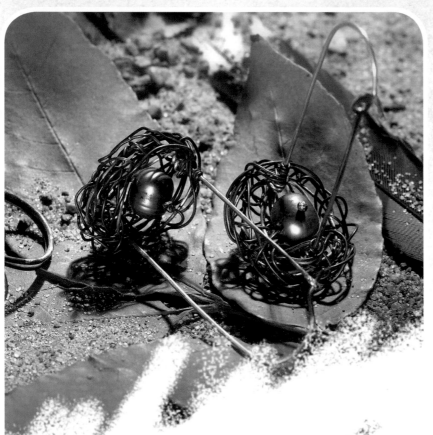

JEWELRY

BIRD NEST RING AND EARRINGS

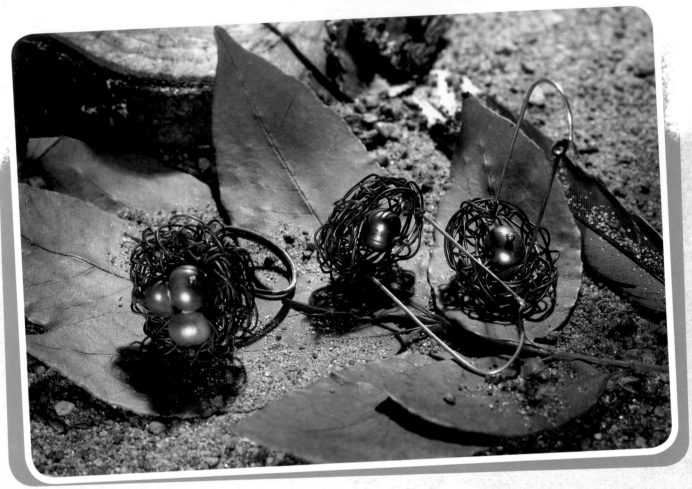

BIRD NEST RING AND EARRINGS
From Semiprecious Salvage *by Stephanie Lee*

We've been excavating in a thick grove of trees. It's been a relief to have shade and find our endurance extended, resulting in longer days of comfortable labor. We have not found much of major significance, but have found ourselves the target of a nesting bird's frustrations. We must be making too much racket for her to peacefully build her nest. In the echo of her petulant squawking and daredevil swooping at our hats, we found our patience tested and left camp for the day.

Upon our return this morning, I was instantly aware of the quiet of the canopy. No squawking. No swooping and screeching. Despite her annoying antics, I found myself hoping she was nestled in somewhere, resting and readying herself for motherhood. I happened to glance up and catch sight of her leaving a branch not far above me. In a plucky spurt of youthfulness, I clambered up the tree to scout out her new home.

I found a tiny nest made of grass, twigs and the string I used to tie my hair back and which I thought had been lost in the dirt. Within lay three vivid blue eggs. I wanted to pick them up and feel their silky smoothness but I knew better than to disturb her home. The moment of observation was cut short by her return. Not wanting to feel the sharp end of her anger, I shimmied down the tree just as she discovered my presence. She swooped at me and I jumped the last few feet taking shelter under the cover of the dig site tent, not a moment too soon. She retreated to her nest leaving a few exasperated screeches in the air.

Truce, little bird.

~ Stephanie

» RING «

materials needed

Wire cutters

Needlenose pliers

Large dowel or paintbrush

Jewelry hammer

Paintbrush

Steel block

Freshwater pearls, 3

Sterling wire, 24-gauge (or 3–3" headpins)

Sterling wire, 18-gauge

Copper wire, 22-gauge

Blackening solution

Latex gloves

Rag or paper towel

Sandpaper, 400 grit

Note

Because freshwater pearls are somewhat soft inside, if the holes aren't quite big enough for the wire, you can enlarge them with a pearl reamer.

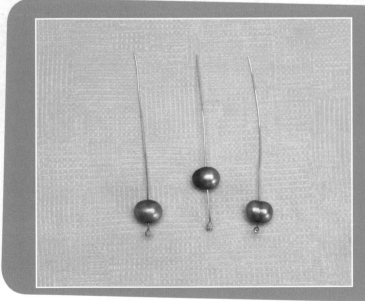

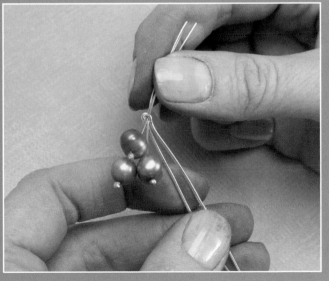

1 THREAD THE "EGGS"

Cut three 3" (8cm) lengths of 24-gauge silver wire. Draw a bead on one end of each by heating the silver wire with a torch. (You can use three 3" headpins if you prefer.) Sand the beads lightly, then string one pearl on each piece.

2 ADD THE RING SHAFT

Cut a 6½" (17cm) length of 18-gauge sterling wire and bend it in half, creating a small opening. Thread all three pearl wires through the opening.

3 SECURE THE EGGS

Wrap each pearl wire around the folded wire, just below the opening, a couple of times for each. Make sure to wrap snugly against the pearls to keep them from sliding away from the wire-drawn bead.

4 CREATE THE RING FORM

Curve the folded wires around a large dowel or paintbrush to create the ring form, then adjust it as necessary to the size you want.

5 CLOSE THE RING FORM

Wrap the ends of the wire back around the base of the pearl wrap.

6 HAMMER THE RING

Hammer the ring on a metal block to flatten it.

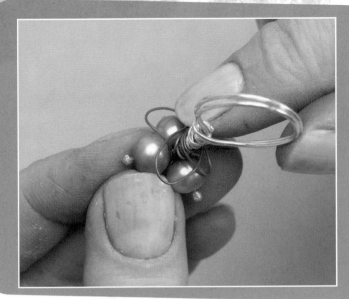 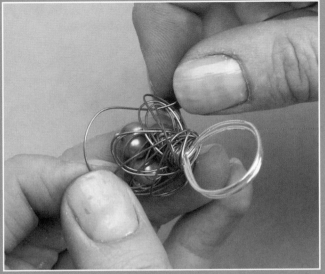

7 BEGIN THE NEST

Cut a 4' (1m) length of copper wire and wrap one end around the pearl wrap to secure it. Begin forming "petals" around the pearls by making a loop, wrapping it around and then making another petal, to begin forming the nest.

8 ADD TO THE NEST

Continue making petal shapes, with each new row of petals getting larger as you go around. Make about five of these rows to create the basic bowl shape that will become the nest. Then, begin weaving the wire randomly in and out of the loops as you work around the pearls.

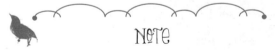

NOTE

For added interest, mix metals and gauges of wire. Brass, silver, copper and annealed iron wire all work well for the nest form. Only copper and silver will allow you to draw a bead onto it, so it's a good idea to start with one of those to thread the pearl onto, then add the other wires as you are weaving the nest.

9 FILL IN THE NEST

Keep weaving around, randomly picking up different sections of the nest as it builds and continue until the nest has the fullness you want. When you run out of wire, tuck the end in and crimp it, and start with a new length, securing it with a crimped hook to start. Lastly, create tie loops that wrap around the wires vertically, loosely securing the larger wraps and creating additional dimension and strength.

10 FINISH THE NEST WRAPPING

Continue looping the wire vertically until the nest looks finished. To finish with the wire, just make a couple of small loops and tuck the end in.

11 AGE THE RING

Brush on the blackening solution. Let it sit for a moment and then wipe off the excess. If desired, lightly sand parts of the nest with 400-grit sandpaper to highlight areas.

»> EARKINGS «<

materials needed

Wire cutters	Torch
Jewelry hammer	Freshwater pearls, 2
Pliers	Sterling wire, 18-gauge
Drill with $1/16$" (2mm) bit	Copper wire, 22-gauge
Dowel or paintbrush	Blackening solution
Steel block	Latex gloves
Metal file	Rag or paper towel
Paintbrush	Sandpaper, 400 grit

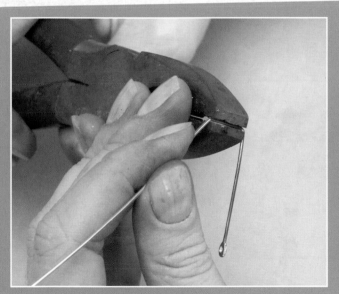

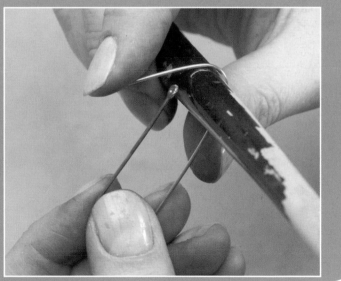

1 DRAW A BEAD ON THE EAR WIRE

For the earrings, begin by cutting two $5^1/2$" (14cm) lengths of 18-gauge sterling wire. Draw a large bead on one end of each piece by heating the silver wire with a torch. Allow the beads to cool. Hammer each bead flat and mark and drill a hole in each. Straighten the wire as much as possible. From the bead end, measure down $1^1/2$" (4cm) and bend the wire at a 90° angle. Then measure another $1/2$" (13mm) and make a second 90° bend.

2 SHAPE THE EAR WIRE

Create a curve in the wire at about $1^1/2$" (4cm) up from the last bend, using a dowel or paintbrush.

3 TRIM THE EAR WIRE

Bend the end of the wire so that it meets up with the drawn bead. With the wires overlapping, trim the end to about ¼" (6mm) below where the bead is on the other end of the wire.

4 CREATE THE CLOSURE BEND

Kink the end of the wire a bit, slightly above where it will go through the hole in the drawn bead, and make sure it will insert into the hole easily.

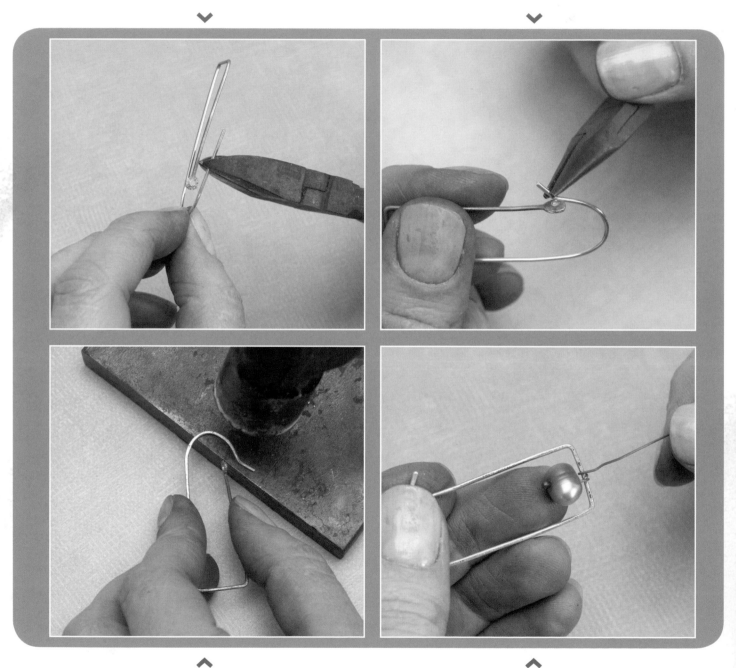

5 FINISH THE EAR WIRE SHAPE

Insert the end of the wire into the hole in the bead and lightly hammer the wire. When you come to the area where it hooks together, remove the wire from the hole and hammer the wire end a bit. File the tip of the wire to remove any sharpness.

6 ADD THE EGG

Cut a 2" (5cm) length of copper wire and draw a small bead on the end of it. Thread the wire through one of the pearls and then wrap the wire around the horizontal portion of the ear wire. Hold the egg away from the bottom of the ear wire just a bit to allow the nest to be built up under it.

7 SECURE THE EGG

Bring the wire up even with the pearl and wrap it around one side wire, back around the wire the pearl is sitting on, then back up and around the wire on the other side. This will prevent the pearl from tipping.

8 START FORMING THE NEST SHAPE

Now, take the wire back to the other side and wrap it around the opposite wire, leaving a loop. Repeat, going back to the other side again, leaving another loop. Repeat this process until you have about four or five loops, making each loop a little larger than the one before. Keep in mind that the finished nest will be slightly larger than this form, so make it a little smaller than you want it initially.

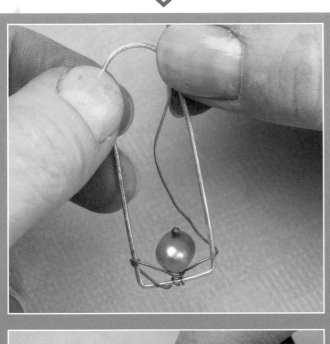

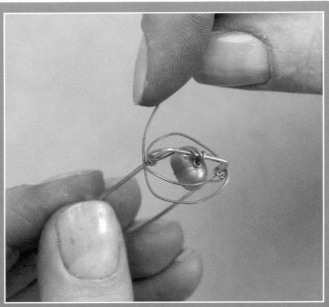

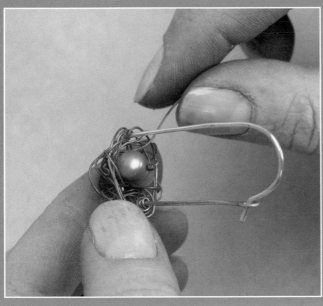

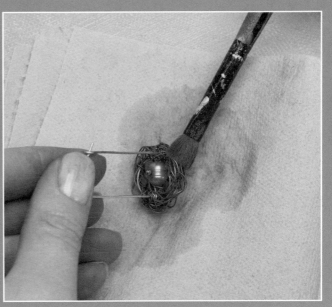

9 WEAVE THE NEST

Like in the ring, start weaving the wire through the loops and in random directions to form the nest. Leave plenty of space outside of the pearl, and periodically loop the wire around the silver wire at the bottom and on the sides. Cut a second length of wire if you need it, securing the old and new ends by crimping them discreetly inside the nest. Continue wrapping until the nest is as dense as you would like it.

10 PATINA THE EARRINGS

Finally, brush on blackening solution. Let it sit for a bit, then wipe off the excess, sanding lightly to highlight raised areas, if desired.

visit createmixedmedia.com/crafty-birds for extras

HIS WINGS NECKLACE

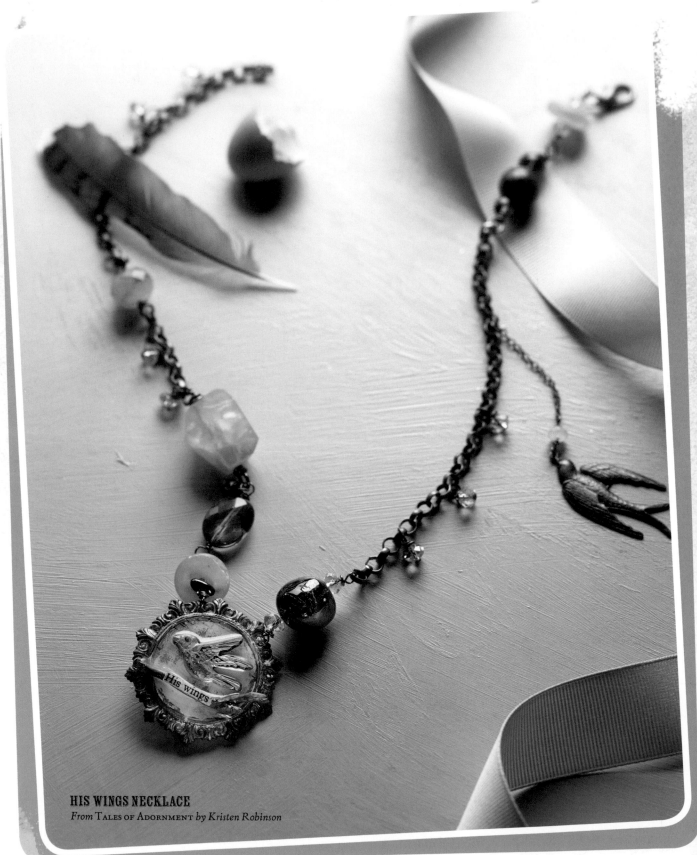

HIS WINGS NECKLACE
From Tales of Adornment by Kristen Robinson

"Father! Father, look!

"There he is, flitting about in the sky again. What is he looking for, I wonder. He is dancing about as if he has no place to be. Perhaps he is playing."

Watching his young son run across the hill, reticule in hand and full focus directed on the small bird, he could not help but laugh out loud. Interest in birds was not something he had ever considered an amusing pastime; however, in recent days he had found himself as enthralled as his eight-year-old son.

Until recent days he had never paused long enough to look up into the blue sky. Upon his son's insistence he had pulled the dusty books about birds from their shelves and began researching with the wee lad by his side.

Something magical did occur when a bird took flight—magical and, frankly, quite amazing. One could not help but watch with interest and wonder as the bird rose from its perch and danced with the breeze, not always leading the dance, but dancing all the same.

There was something to be said for leaving his law books and parliamentary documents aside for a day in the park watching the birds soar about on their delicate wings, or as his son would say, "dance upon the deep blue of the summer sky."

~ Kristen

materials needed

Resin reticule (two-part resin, craft sticks, small plastic cups, craft sheet, paper towels, sanding tools)

Jeweler's reticule (round-nose pliers, flat-nose pliers, chain-nose pliers, tweezers, scissors, flush cutters, wire cutters)

Bezel

3mm Golden Shadow crystals, 6 (Swarovski)

3mm Crystal Moonlight crystals, 3 (Swarovski)

2mm faceted peridot beads, 2

1.5cm center-drilled peridot beads, 2

Pebble garnets, 2

14mm × 10mm faceted green quartz nugget bead, 1

10mm center-drilled oval faceted lemon quartz bead, 1

8mm round peridot bead, 1

1.5mm round smoky quartz bead, 1

3mm faceted smoky quartz bead, 1

1.5cm faceted smoky topaz bead, 1

1cm round garnet, 1

$1^{1}/_{2}$" (4mm) brass bird

Small acrylic bird

3mm bronze chain

1mm bronze chain

5mm bronze jump ring, 1

3mm bronze jump ring, 1

22-gauge gunmetal headpins, 9

22-gauge gunmetal wire

$1^{1}/_{2}$" round metal bezel

Bronze lobster claw clasp

Twig

"His Wings" printed onto ledger paper

Scrap of sheet music

Acrylic paint in crème, burnt umber, red and black

Drill with a $1/_{16}$" (2mm) drill bit

Glue stick

Gold paint pen

Paper towel

Scrap piece of wood

Small paintbrush

1 PAINT THE BIRD CHARM

Using a small paintbrush, apply a layer of red paint to the acrylic bird. Let dry for five minutes and wipe off the excess with the paper towel. Repeat this step with the black and burnt umber paints.

2 EMBELLISH THE BIRD CHARM

Allow the paints to fully dry. Embellish the bird with a few specks of gold with the gold paint pen. Allow the bird to dry.

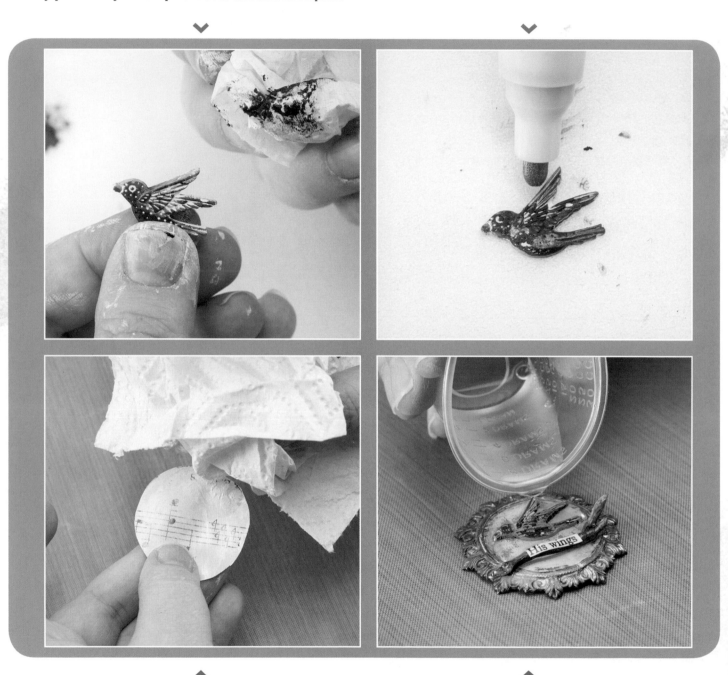

3 CUT AND PAINT THE DECORATIVE PAPER

Cut a scrap of sheet music to fit into the bezel. Using the crème acrylic paint and a dry paintbrush, paint the paper and wipe off the excess paint with a paper towel. Let the paint dry.

4 FILL THE BEZEL

Glue the paper and then the bird into the bezel (see sidebar, *Placing Imagery or Objects*). Toward the bottom of the bezel, glue a small twig, and to the twig glue a scrap of ledger paper printed with the words *His Wings*. Prepare your work surface. Mix ¼ ounce of two-part resin and pour it into the bezel (see sidebar, *Mixing Resin*). Be sure not to overfill and make sure there are areas of the stick that protrude from the resin. Let the resin cure for 24 hours.

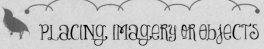

PLACING IMAGERY OR OBJECTS

*Use this technique any time you want to add an extra
layer of interest to your resin jewelry designs.*

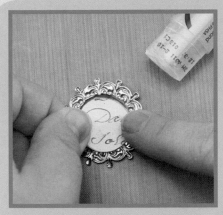

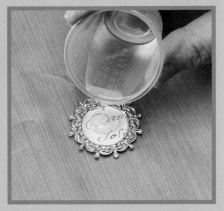

Print or stamp your imagery or text on the
desired paper. Cut it so it will fit in the bezel.
Using a glue stick, secure the imagery or text
in the bezel.

Mix and pour resin into the bezel, stopping at
the top of the bezel so the resin does not overflow.

MIXING RESIN

*Mix and pour resin any time you want to add an extra
layer of interest to your jewelry designs.*

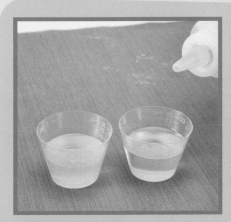

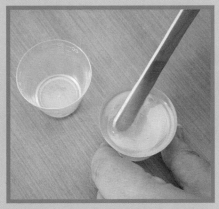

In small plastic cups, measure the two-part resin
according to the manufacturer's directions.

Combine according to the manufacturer's directions and stir as directed. Use a disposable craft
stick and gently fold the resin parts together to
avoid creating bubbles.

visit createmixedmedia.com/crafty-birds *for extras*

5 DRILL HOLES THE IN BEZEL

Place the bezel on a scrap piece of wood. Using a drill fitted with a ¹/₁₆" (2mm) drill bit, drill two holes at the top of the bezel, 1" (3cm) apart from each other.

6 ADD THE WRAPPED LOOP LINK

Begin working on the left side of the bezel. Using a 3" (8cm) piece of 22-gauge gunmetal wire, create a wire-wrapped loop link using a pebble garnet, a 1.5cm center-drilled peridot bead and another pebble garnet (see sidebar, *Making a Wrapped Link*). Place the first loop through the left hole of the bezel before you close the loop.

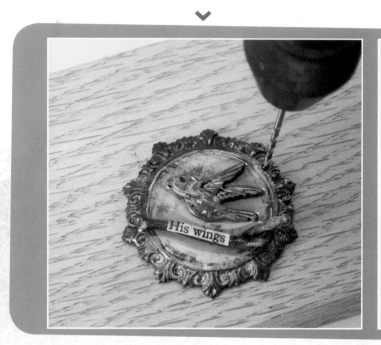

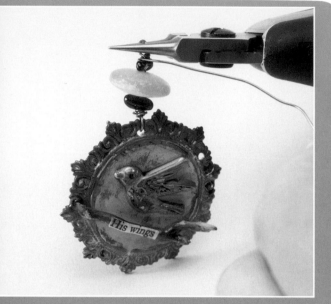

MAKING a WRAPPED LINK

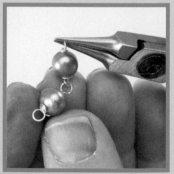

1 Using the length and type of wire specified in the project instructions, form a loop in the wire at least 1" (3cm) from the wire end. To do this, use round-nose pliers to turn the wire, creating a loop.

2 Bring the tail around the loop. Trim the excess wire.

3 Thread on the bead. Repeat steps 1 and 2 to complete the link.

4 Repeat step 1, this time threading the wire through the loop of the previous link before wrapping. Complete steps 2–4 to complete the link. Repeat steps 1–4 until you've reached the desired length of the chain.

7 ADD ADDITIONAL WRAPPED LOOP LINKS

Using the 22-gauge gunmetal wire, add the following individual wire-wrapped loop links to the pebble garnet-peridot link: one 1.5cm faceted smoky topaz bead and one 14mm × 10mm faceted green quartz nugget bead. Before closing the final loop, add a 1 1/2" (4cm) length of 3mm bronze chain.

8 ADD THE WRAPPED DANGLES

To the end of the 1 1/2" (4cm) length of chain, add a wrapped link using the 10mm faceted lemon quartz bead. Before closing the final loop, add a 4 1/2" (11cm) length of 3mm bronze chain and place it through the open loop of the lemon quartz link.

Using six 22-gauge gunmetal headpins and six Golden Shadow crystals, make dangles, attach the dangles 1" (2.5cm) apart, starting with the one attached to the top loop of the green quartz link (see sidebar, *Making a Wrapped Dangle*).

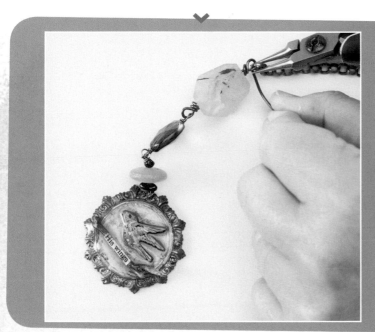

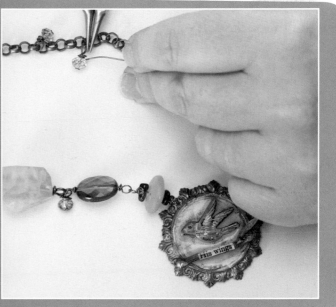

MAKING A WRAPPED DANGLE

1 Thread a bead onto the head pin.

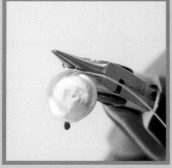

2 Using the round-nose pliers, turn the wire around the jaws to form a loop.

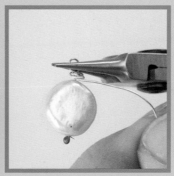

3 Wrap the wire tail around the wire.

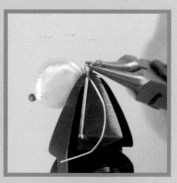

4 Trim the excess wire.

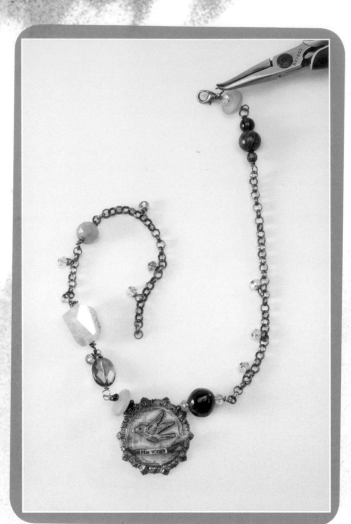

9 CONTINUE CREATING THE CHAIN AND ADDING LINKS AND DANGLES

To the right side of the pendant, create the remaining portion of the neck chain using the following wrapped links and sections of chain:

Wire-wrapped link with one 3mm Crystal Moonlight crystal, one 1cm round garnet and one 3mm Crystal Moonlight Crystal; 5 ½" (14cm) of 3mm bronze chain; a wrapped link with one 3mm faceted smoky quartz bead, one 8mm round peridot bead and one 5mm round smoky quartz bead; a final wire-wrapped link with one 3mm Crystal Moonlight crystal, one 1.5cm center-drilled peridot bead and one 2mm faceted peridot bead.

To the end of the last wrapped link, attach the bronze lobster claw clasp using the 5mm bronze jump ring (see sidebar, *Opening and Closing Jump Rings*).

Using the remaining headpins, add three Golden Shadow crystal dangles to the chain portion.

OPENING AND CLOSING JUMP RINGS

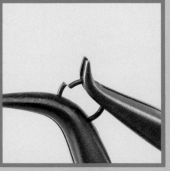

1 Using two pairs of pliers, grip the jump ring on either side of the cut ends. Using a scissor motion, open the jump ring.

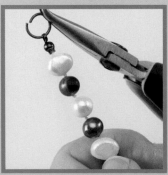

2 Slide on any desired objects.

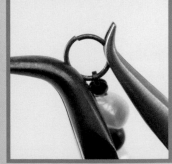

3 Close the jump ring by gripping it as you did in step 1 and bringing the cut ends back together.

10 ADD THE BIRD CHARM TO THE CHAIN

Create a wrapped link using the 22-gauge gunmetal wire and the 2mm faceted peridot bead. Attach it to the bird charm, Then, before closing the final loop, thread on a 1 1/2" (4cm) length of 1mm bronze chain.

11 JOIN THE FINAL LINKS

Open one 3mm bronze jump ring and attach it to the bronze chain 1/2" (1.5cm) down from the peridot and smoky topaz link. With the jump ring open, attach 1 1/2" (4cm) of 3mm bronze chain.

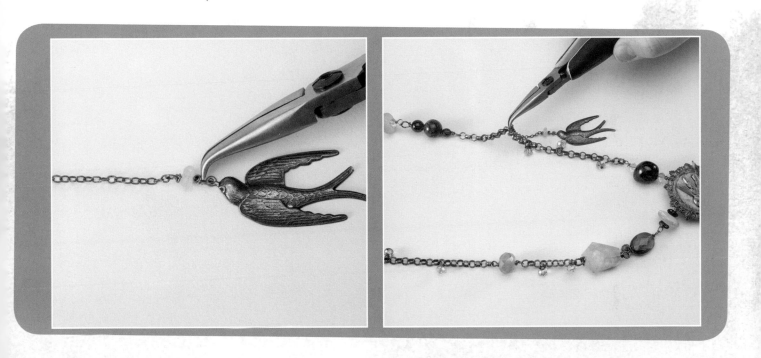

BROKEN HEART NECKLACE

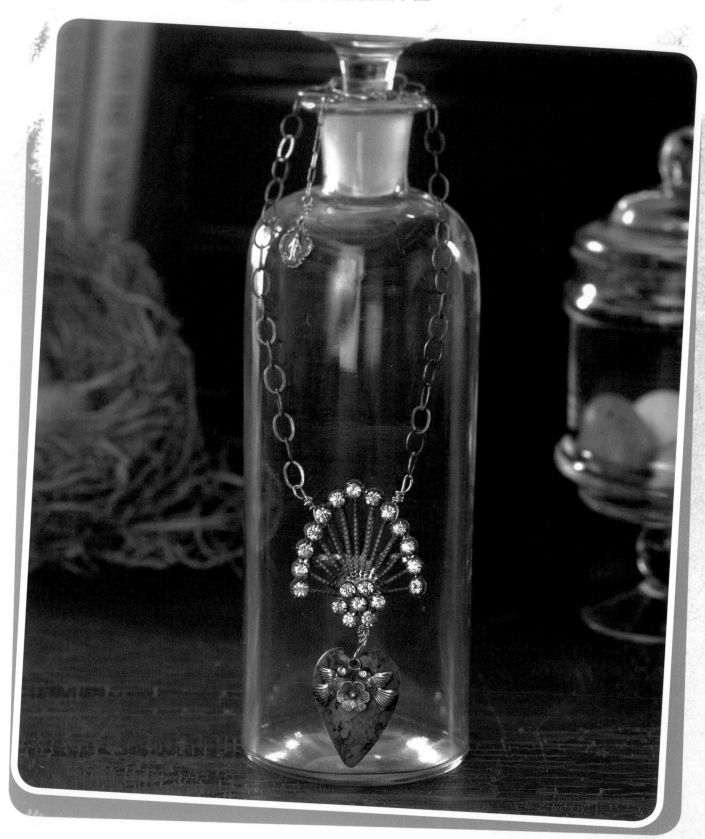

BROKEN HEART NECKLACE
From Inspiritu Jewelry by Marie French

I was doing a research paper on *curanderas*—healing women in West Texas—and stumbled upon a curandera named Milagros who lived there in the 1930s. Milagros, it is said, practiced Miracle Thinking and made jewelry to heal the sick and mentally ailing. The story that accompanies this project comes from Milagros' old prescription book, a leather-bound book with the names of her patients, illnesses and the how-to information for making her healing jewelry.

~*Marie*

Journal Entry ~ November 21, 1924

I had to drive to visit a client at her home today. I was told of a young person who would not leave her family's ranch and was despondent. I drove nearly two hours through the mountainous terrain and desert scrub. I drove down the rocky, bumpy road for two miles, and there in the distance was the ranch house. Just as I pulled up, the mother greeted me at the car. The girl had a sunken, apathetic expression, slow moves and was just seemingly dead to everything around her.

I was told the girl had come home, about a week ago, crying and inconsolable. It turns out her friend had had convulsions at school and they had to take him to the hospital. That night she got a call, and his parents explained that he had died in the hospital. That is when she had shut down. He was her first love. It seems no one could help her out of her despondency, or even raise any sort of emotion from her. She seemed to have lost her will to live.

materials needed

- Miraculous medal (such as a saint medallion or any meaningful Milagros)
- 3" (8cm) fine found sterling chain
- Sterling wire, 24-gauge
- 5" (13m) medium found sterling chain, 2
- Small bead
- Round-nose pliers
- Wire, 16-gauge
- Hammer
- Steel bench block
- Chain-nose pliers
- Double-bird charm
- Heart-shaped turquoise stone
- Rhinestone shoe clip or necklace piece

INTENTION:
MAY I REMEMBER
THAT IT IS IN LOVING,
THAT ONE IS LOVED

MATERIALS AND WHY I CHOSE THEM:

Miraculous medals—love, protection, miracles
Sterling silver—innate power
Turquoise heart—healing
Bird charm—love birds
Rhinestone—light and radiance
Sacred heart—love

1 ADD THE MEDAL TO THE CHAIN
Wire wrap the miraculous medal to the 3" (8cm) chain.

2 JOIN THE CHAINS
Wire wrap the chain to one of the 5" (13cm) pieces of chain, adding a bead to the connector.

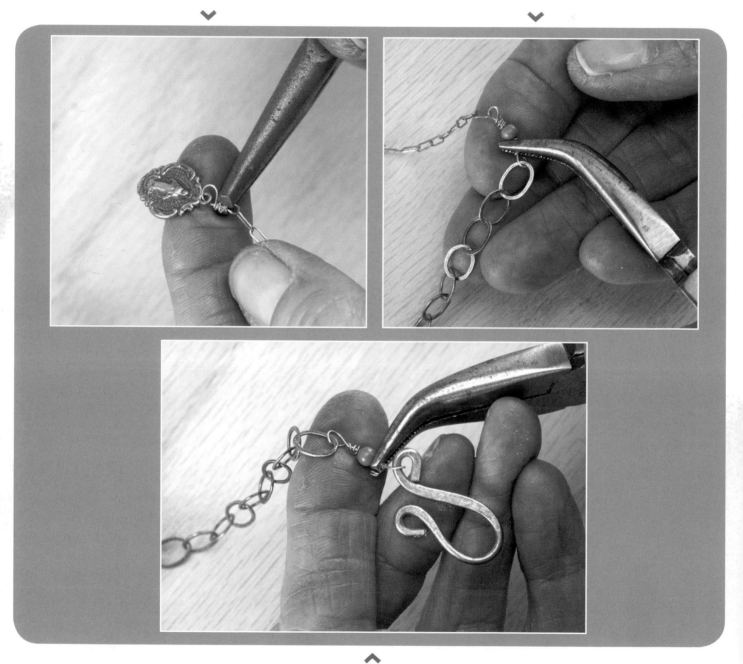

3 CREATE AND ATTACH A CLASP TO THE CHAIN
With the round-nose pliers create a U-shape in 16-gauge wire, with small loops on the ends. Hammer the U-shape flat for strength. Repeat with a second piece of wire, making the U a bit lopsided. This second piece will act as the hook. Using chain-nose pliers, wire wrap one half of the clasp near the place you connected the smaller chain. Wire wrap the hook to the other piece of 5" (13cm) chain using the chain-nose pliers.

4 CREATE THE CENTERPIECE

Wire wrap the double-bird charm onto the turquoise heart, then wire wrap the rhinestone shoe clip onto the other half of the connection wrap.

5 JOIN THE CENTERPIECE TO THE CHAIN

Wire wrap one half of the chain to the rhinestone shoe clip, about one-third of the way in, using jewelry pliers. Repeat on the other side of the shoe clip, with the other half of the chain.

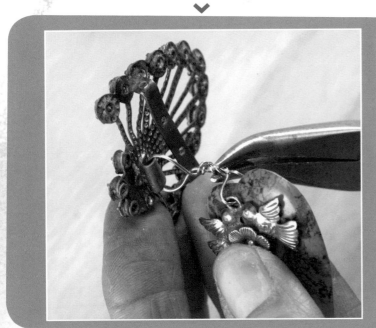
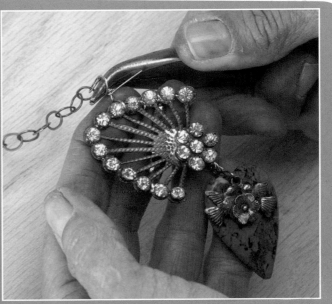

Journal Entry ~ December 23, 1924

I just got a call from the girl at the ranch. She wanted me to know that she had formed a group at school called the Lonely Hearts Club. It is a club for those who have lost someone or who felt lost. The club volunteers at hospitals, nursing homes and anywhere else they are needed to share and care. They bake cookies, read stories, but most of all they just share beauty and companionship. Yes, she said everything is great in her life. She even has a new boyfriend.

›› GUARDIAN CUFF

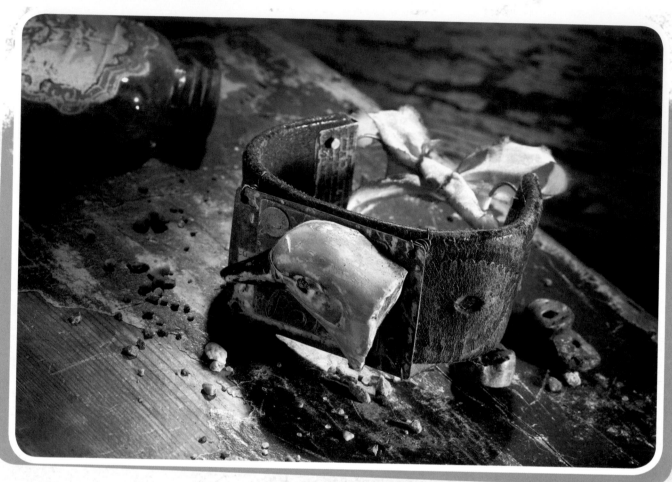

GUARDIAN CUFF

From SEMIPRECIOUS SALVAGE *by Stephanie Lee*

Today presented a most mysterious find. One would think that because we don't know specifically what we are digging for, that everything we find would be mysterious. This is not the case as many unearthed objects are self-apparent (a spoon, pottery or a piece of jewelry).

A reliquary of sorts, not much larger than my hand, was found in an empty chamber. Considering the material it was made of, it was surprising that it had survived for so long. Leather—thick, dark, oiled leather. Not a likely material to find preserved so well. It was crafted with precision joinery, which I have not yet been able to identify. On the lid, a beautiful carved bird stands sentinel over what may lie within. It is empty and my mind wanders, imagining what could have been deemed valuable enough for such a hiding place. Where did the box come from? A trader from a neighboring village, a sailor from another land? How very curious.

~ Stephanie

Wire cutters

Sharp scissors or leather snips

Ruler or other straightedge

Marker

Torch

Drill with 1/16" (2mm) bit

Craft knife

Steel hammer block

Hammer

Metal file

Center punch

Dremel tool with wire brush attachment

Rag or paper towel

Eyelet or rivet setter

Cotton swabs

Sculpey brand clay (use the white, oven-dry variety but do not bake it)

Bird form (such as a plastic or wood toy or ornament)

Vintage leather belt

Plaster of Paris, 2–3 tablespoons

Wood glue

Water

Pre-etched nickel sheet

Aged metal

Tiny nuts and bolts, 4

Book text

Gel medium

Copper wire

Sterling wire, 18-gauge

Acrylic paint and paintbrush

Clear caulk

Ribbon

Clothespin

Spray sealer

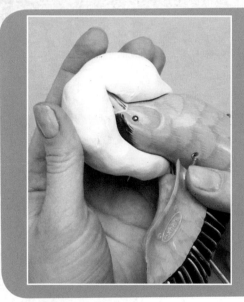
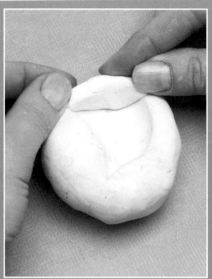
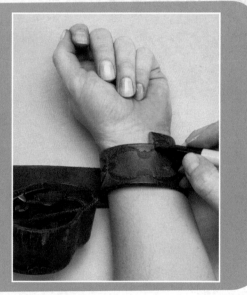

1 CONDITION THE CLAY

Condition a lump of clay and press the head portion of a bird into the clay. Gently remove the bird head revealing a clean impression to cast plaster into. Only press the head halfway into the clay to create a nice, flat back on the finished bird head.

2 CREATE A CASTING WELL

Seal off the open side with additional clay, to create a complete enclosure for the plaster.

Mix a slightly runny consistency of plaster of Paris. Add about 1/8 teaspoon of the wood glue to the dry plaster, then a small amount of water. Mix vigorously to eliminate any lumps. Slowly add more water until the plaster is the consistency of buttermilk. Fill the mold half full with the plaster and then tap the mold against the table a few times to bring any bubbles to the surface. Fill the rest of the way and set aside to cure.

3 SIZE THE CUFF

Measure the circumference of your wrist and mark it on the belt.

4 CUT THE LEATHER

Cut the belt 1" (3cm) shorter than where you marked it with the pen to allow for the addition of the closure.

5 CUT ETCHED PIECES FOR CLOSURE

Cut two pieces of etched nickel sheet 1 1/8" (3cm) times whatever the width of your belt is minus 1/8" (3mm). So, for example, if your belt is 1" (3cm) wide, cut each piece of nickel to 1 1/8" × 7/8" (3cm × 2cm). Hammer the metal pieces and file the edges, removing any burrs and the sharp corners. Draw a line on the back of each piece, down the center of the 1 1/8" (3cm) length.

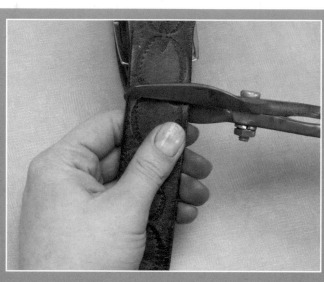

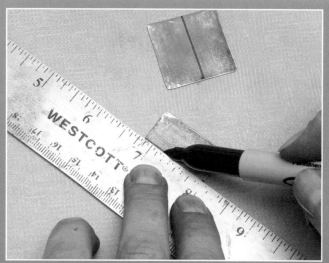

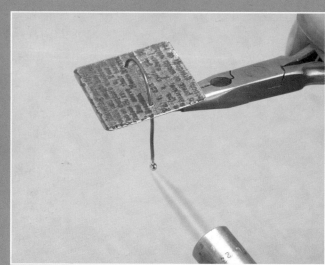

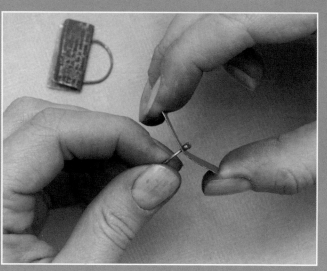

6 ADD THE WIRE LOOPS

Using the center punch, mark a hole on the line at 1/4" (6mm) from each end. Do this for both pieces. Drill holes at the marks and tap the backs of the holes with a hammer. Cut two 2" (5cm) lengths of 18-gauge sterling wire. Draw a bead on the end of each piece of wire by heating it with a torch. Thread one wire through one of the holes from the back. Create a loop and thread it through the other hole, then draw a bead on that end by heating the metal with a torch. Repeat for the other wire and metal piece.

7 FOLD THE METAL END CAPS

Fold the metal pieces in half along the line where the holes are.

8 MARK THE END CAPS FOR DRILLING

Push the folded metal pieces onto the ends of the leather. Mark for two holes, using the center punch, 1/4" (6mm) in from each bottom corner. Drill at one of the holes.

9 SECURE THE END CAPS TO THE LEATHER

Insert a bolt from the inside to the outside and secure a nut onto the end of it. Tighten it just enough to make contact. Drill the other hole, insert the other nut and secure its bolt. Tighten both of the bolts. Repeat for the other end of the cuff.

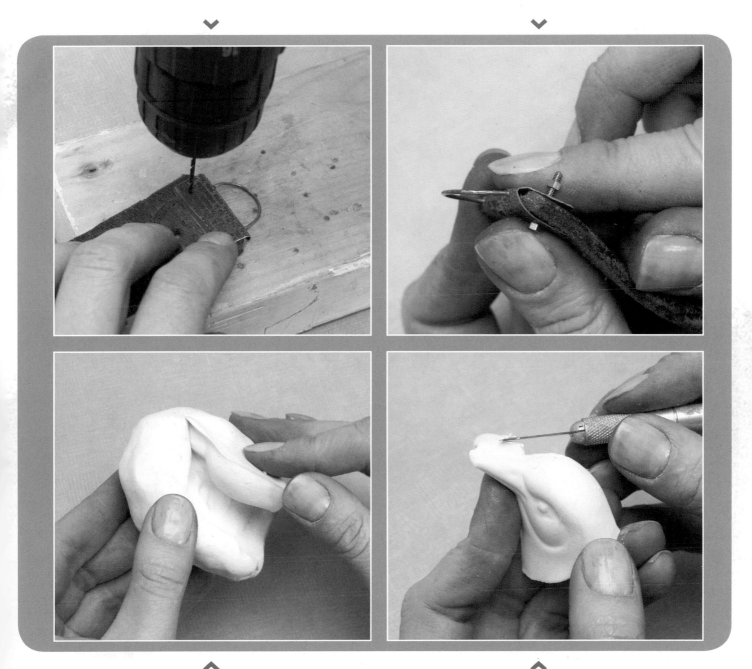

10 REMOVE THE PLASTER FROM THE MOLD

Snip off the excess bolt lengths and file the burrs. Soak the cuff in water for a minute, then remove it and use a clothespin to secure the cuff together while it dries. When the plaster has set, remove the bird from the clay mold.

11 CLEAN UP THE CAST PLASTER

After a few hours in the warm summer sun, 10–15 minutes in an oven set on its lowest temperature or a day or so in room temperature, the plaster will be completely cured. Use a craft knife to scrape away the excess plaster seam.

12 PAINT THE BIRD HEAD

Use the Dremel and the wire brush attachment to remove any uneven texture on the back of the bird casting. It should be nice and flat to assure good adhesion later. Paint the plaster however you like, using acrylic paint. Use a paper towel to dab off any excess paint.

13 PREPARE THE METAL BACKPLATE

Cut a piece of aged metal to accommodate the bird casting no wider than the width of the belt. Hammer and file the piece of metal. Use gel medium to adhere a piece of book text to the metal. Cut a scrap of etched metal. Attach the scrap to the aged metal by drilling two corresponding holes in each piece and setting eyelets or rivets into the holes.

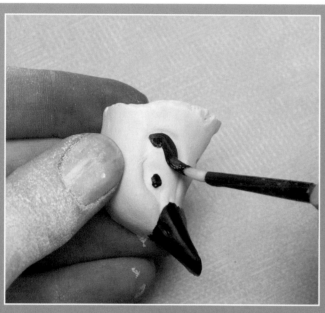
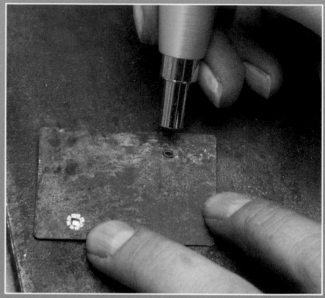

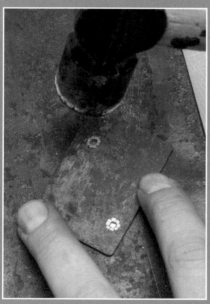
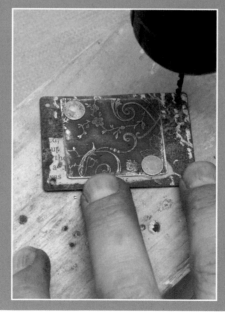
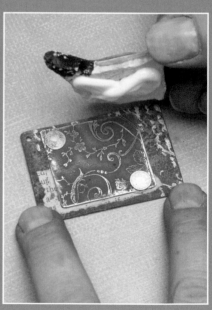

14 FLATTEN THE EYELETS

Place the metal facedown on the steel block and hammer the eyelets or rivets flat, from the front and the back.

15 DRILL FOR THE ATTACHMENT

Drill a $1/16$" (2mm) hole in each of the four corners of the aged metal piece.

16 ATTACH THE BIRD HEAD

Glue the bird to the front of the metal with clear caulk.

17 CLEAN UP EXCESS CAULK

Take a cotton swab to work the ooze around the edge of the bird and to seal everything in and to clean it up. Once the caulk has cured, give the whole piece a coat or two of spray sealer.

18 MARK THE METAL FOR ATTACHMENT

Center the piece on the leather and, with a marker, mark where the four corner holes are.

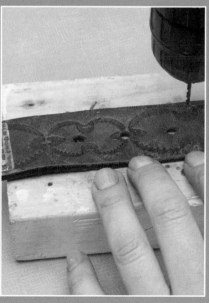

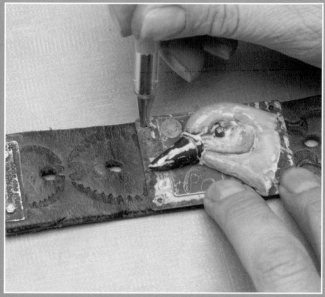

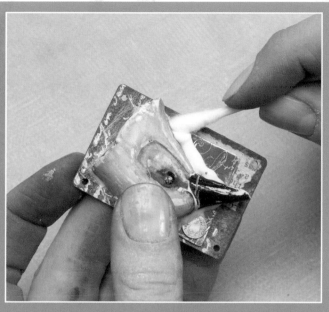

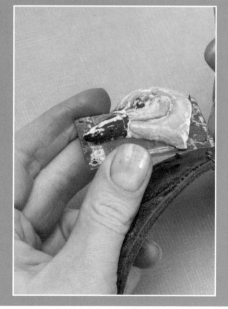

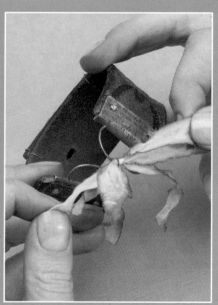

19 DRILL THE LEATHER

Drill a hole at each mark. (Note: Vintage leather can often be fragile so be sure you are not too close to the edge.)

20 ATTACH THE BIRD TO THE LEATHER

Wrap the end of a length of copper wire through one hole on the leather and then thread the metal piece on.

21 FINISH THE CLOSURE

Wrap the wire around the wrap some more, then trim off the excess. Repeat for the other three corners to completely attach the piece to the leather. To wear the cuff, have someone help you tie the two ends together with a silk ribbon.

visit createmixedmedia.com/crafty-birds *for extras*

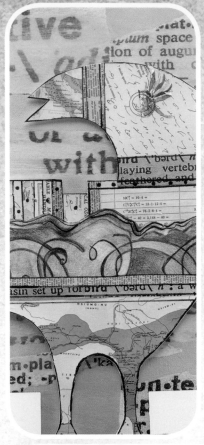

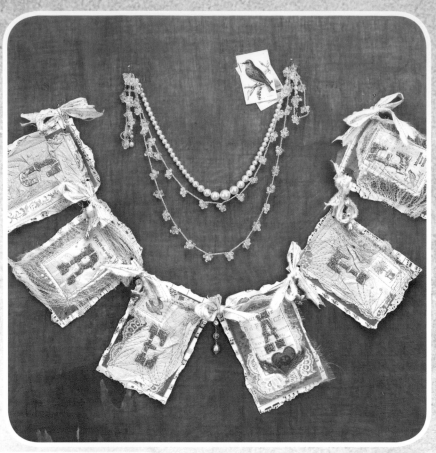

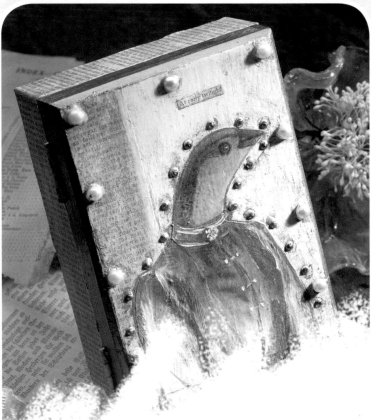

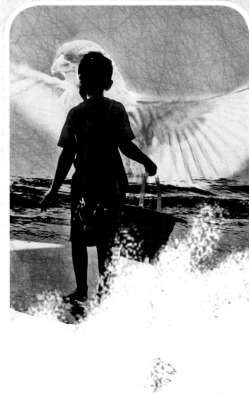

CHAPTER TWO

COLLAGE BIRDS

"CREATE" BANNER

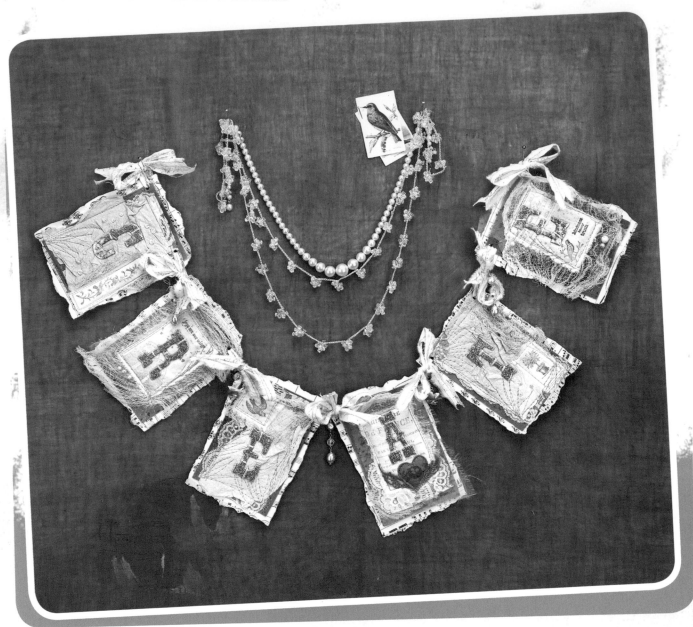

"CREATE" BANNER
From Layered, Tattered and Stitched *by Ruth Rae*

Pennants and banners have roots that date back many centuries. Both, created with fabric, were used to display family lineage and announcements of celebrations and arrivals. In our world today, we see pennants and banners everywhere, from studios and creative spaces to parties and sports events.

A banner is the perfect project to personalize either for ourselves or as a gift to someone dear to us. A word that offers encouragement or a phrase that reminds us why we

do what we do, spelled out in a banner, is a wonderful addition to a wall or passageway.

The simple construction of a banner makes it very appealing. Paper, fabric, ribbons, embellishments and other baubles and trinkets turn a basic piece of artwork into a treasure. We can integrate a time-honored tradition into our daily lives with a little time and a few materials.

~ Ruth

materials needed

Alphabet letters (ready-made, with glitter)

Beads, pearls and crystals

Craft paint

Decorative paper such as
sheet music

Small plastic doves (available
in the wedding section of most craft stores)

Drill with $^1/_{16}$" (2mm) bit

Fabric: cheesecloth, felt, lace, muslin, organza

Fabric dye

Ink: StazOn or fabric ink (timber brown and
saddle brown)

Leather punch

Needle (embroidery)

Paper towels

Pearl cotton #5 (or embroidery floss)

Plastic cup

Water

Pliers (chain-nose, round-nose)

Quilting machine needle, size 14/90

Quilting machine thread

Rubber stamps (deeply etched)

Scissors

Sewing machine

Wire, 24-gauge, any color

Yarn or other fiber (fuzzy)

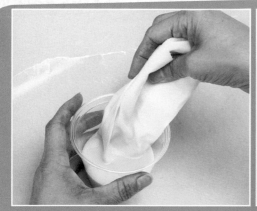 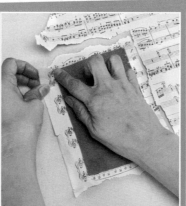 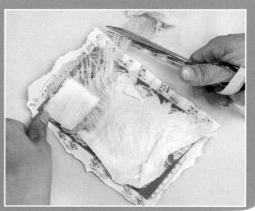

1 PAINT-DYE A PAPER TOWEL

Squirt a dollop of craft paint into a small plastic cup. Dilute it with about $^1/_2$ cup (118ml) of water. Stir, then dip in a dry paper towel.

Squeeze the excess water from the paper towel and set it aside to dry (or iron it). At the same time, dye various scraps of fabric or cheesecloth that you may want to use, too.

2 CUT THE FELT PIECES

Cut out six 4" × 6" (10cm × 15cm) pieces of felt. Create the individual letter pennants in whatever order you like. Start by placing one piece of felt over a sheet of decorative paper (such as sheet music); tear the paper to leave a border around the felt.

3 PREPARE AND ARRANGE EPHEMERA

Lay out elements to decide how you want the pennant to look. If you wish, stamp on a scrap of muslin to act as a little patch. Trim or tear the elements to size and layer.

4 SEW THE LAYERS TOGETHER
Secure the layers (including the muslin patch) to the felt and background paper with free-form decorative stitching.

5 HAND-STITCH THE LETTERS
After layering, sew the letter onto the pennant with a double strand of embroidery floss; simply tack it down in a few places by bringing the thread over the letter.

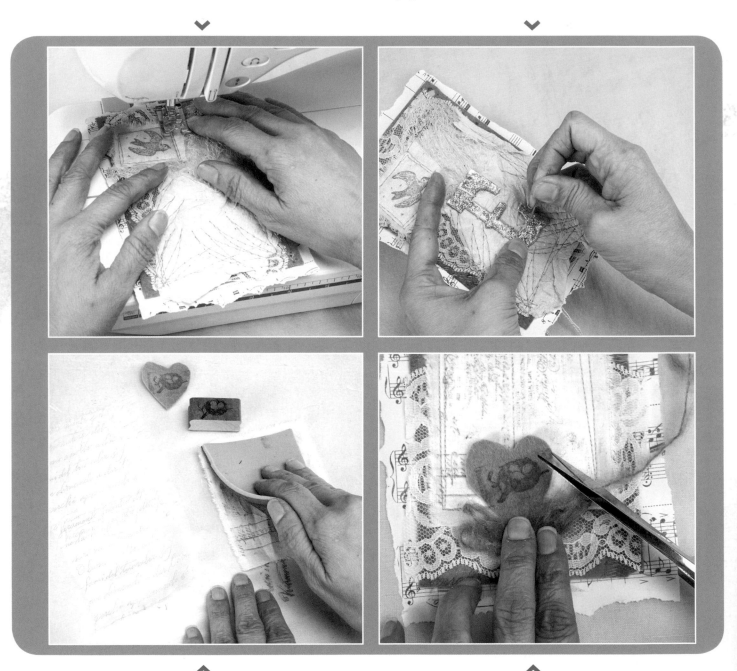

6 CONTINUE STAMPING AND STITCHING
Move on to the next letter pennant. If you plan to use several stamped elements on one pennant, it makes sense to stamp them all at once so they are ready to go.

7 CONTINUE LAYERING AND STITCHING
Again, layer the fabric elements for this pennant the way you want them to look.

Secure the majority of them with the sewing machine. (Hand-stitching some elements adds additional texture.)

Here, I am creating a fiber "nest" for my little heart element. If you'd like to try this, cut several lengths of fuzzy yarn.

8 ADD THE TOP LAYER AND STITCH IT IN PLACE

Secure the heart (or other element that goes in the nest) first. Arrange the yarn around the heart and stitch back and forth over it to secure.

9 CREATE TIES AND STITCH THE PERIMETERS

Stamp on one side of a piece of muslin; on the other side, spatter paint or use a spatter stamp. To create ties for the pennant, tear the muslin into long strips about 1" (3cm) wide. Sew around the perimeter of each strip.

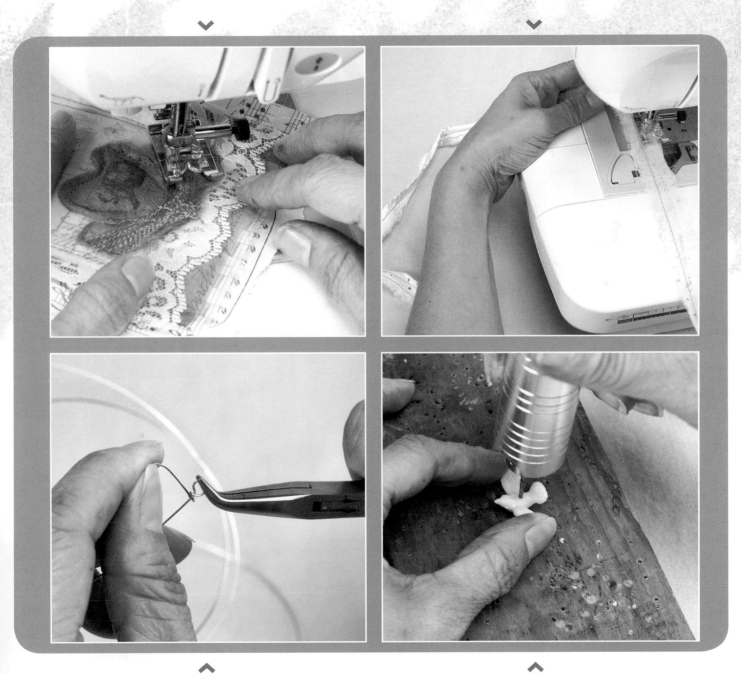

10 CREATE THE BEAD DANGLES

I like to have little dangles hanging from a couple of pennants for added interest. For this piece, I'll make a small nest. Start with 36" (91cm) of 24-gauge wire. About 2" (5cm) from one end, form a small loop with round-nose pliers. Grasp the loop with chain-nose pliers and wrap the tail of the wire around the base of the loop.

11 TOP DRILL ONE OF THE DOVE CHARMS

Drill a hole through one of the plastic doves using a 1/16" (2mm) drill bit.

visit createmixedmedia.com/crafty-birds *for extras*

12 BEGIN FORMING THE NEST
Thread the dove onto the wire so that the eye loop is on top of the dove. Bend the wire down flat against the dove's bottom and secure it with your thumb. Coil the wire to form a base for the nest.

13 ADD BEADS TO THE NEST
Thread about twenty seed beads onto the wire. Coil the wire some more, working in the beads as you go.

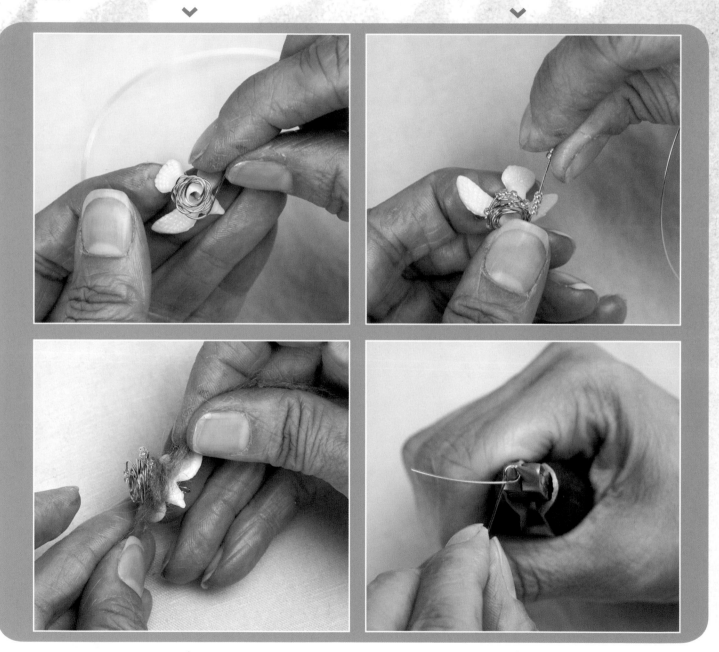

14 FINISH THE NEST
When the nest is as full as you want it, coil the wire back up the nest and trim it close against the bottom of the dove. Tie a piece of fuzzy yarn between the bottom of the dove and the nest.

15 CREATE A WIRE LOOP
Cut a 3" (8cm) length of 24-gauge wire. Using round-nose pliers, create a small loop about ³/₄" (19mm) from one end.

16 CROSS AND BEND THE WIRE

Where the wire starts to cross itself, grasp it inside the loop with chain nose pliers. Bend the loop up to center it over the wire.

17 WRAP THE WIRE AROUND THE LOOP

Grasping the loop flat with chain nose pliers, wrap the tail of the wire around the base of the loop about three times.

18 TRIM THE WIRE

Trim the excess wire.

19 THREAD A BEAD AND WRAP

Thread a bead or crystal onto the wire. Bend the wire down 90°. Near the hole of the bead form another loop with the round-nose pliers.

20 ADD A WRAPPED BEAD TO THE DANGLE
Thread the loop of the bead or crystal onto the dangle. (Here, I am linking it to the dove-nest charm.)

21 WRAP AND TRIM THE WIRE
Again, grasp the loop flat with chain-nose pliers and wrap the remaining wire around the base of the bead. Trim any excess.

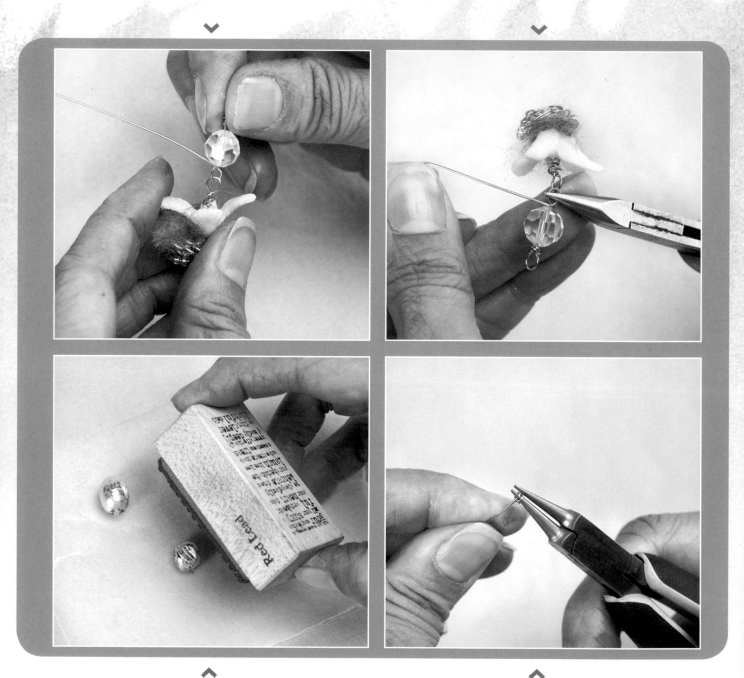

22 STAMP THE BEADS IF DESIRED
For added interest, try stamping on the surface of the beads you'll use for the dangles. Here, I am stamping a variety of beads using a text stamp and StazOn ink.

23 CREATE EYE PINS
To create your own eye pin, start with about 4" (10cm) of wire. Use the tip of round-nose pliers to create a loop, then coil the loop a couple of times.

24 THREAD THE WIRE THROUGH THE EYE PIN
Thread the other end of the wire through the loop in the eye pin.

25 CREATE A KNOT IN THE EYE PIN
Pull the wire taut to create a knot at the end. I find it easier to tighten the knot by pushing a bead against it while tugging the wire.

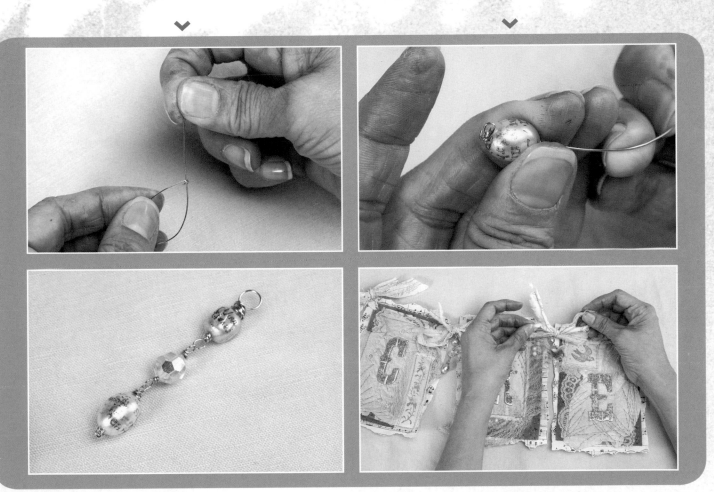

26 CONTINUE ADDING BEADS AS DESIRED
Create a wrapped loop at the other end of the bead. Continue adding rosary-wrapped beads until the dangle is the length you want. (See sidebar, *How to Rosary Wrap a Bead.*)

27 TIE THE PENNANTS TOGETHER
Cut the stamped or spattered muslin strips into lengths about 14" (36cm) long. Punch holes at the top corners of the letter pennants. Tie the pennants together with the muslin strips, threading dangles onto the strips between some of the pennant cards.

HOW TO ROSARY WRAP A BEAD

Begin with a 3" (8cm) length of 24-gauge wire. Using round-nose pliers, make a loop about 1" (3cm) from one end of the wire. Wrap the tail of the wire around the base of the loop. Thread on a bead, then create a loop in the wire at the other end of the bead and wrap the tail of the wire around that loop.

To link, insert the unlooped wire of a bead through the finished loop of a second bead. Make a loop in the wire of the first bead and wrap the tail of the wire around the base of the loop.

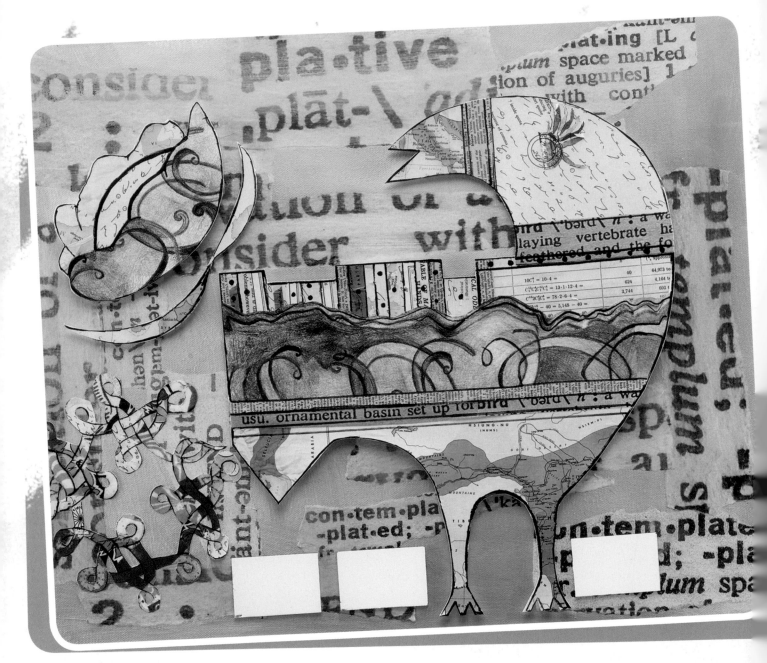

CONTEMPLATE BIRD
From COLLAGE PLAYGROUND *by Kimberly Santiago*

I have an old paperback dictionary I like to use for collage projects because the slightly aged pages add wonderful qualities to my art. The design the words make on the page are art in themselves. When developing this piece, the word *contemplate* jumped out at me. I am forever contemplating art; how about you?

Take a look at the symbol in the lower left corner of the artwork. I pulled it from my stash of collage elements. It was appropriate for this project because it is derived from an ancient symbol meaning *to contemplate*. See what unique imagery you can come up with while digging around in your stash of collage elements.

~ Kimberly

Acrylic paint in blue and white

Palette

Paintbrushes

Gallery wrapped canvas, 12" × 16" (30cm × 41cm)

Dictionary page, *contemplate* entry

Color copier

Copy paper

Matte medium

Putty knife

Pencil

Piece of 100-lb. bristol paper, with a vellum finish, 11" × 14" (28cm × 36cm)

Sheet of double tack mounting film, 11" × 14" (28cm × 36cm)

Fine-tip black marker

Vintage book pages from shorthand and math books

Pieces of unfinished artwork, sketches or drawings

Vintage maps

Scissors

Craft knife

Cutting mat

Vintage postage stamp

Mirrors, 3, 1" × 2" (3cm × 5cm)

COLLAGE ELEMENTS

Altered book pages

Textile featuring a symbol

TIP

Select a variety of papers and don't forget to use your own artwork. Incorporating fragments such as unfinished drawings or sketches gives the collage a degree of personality.

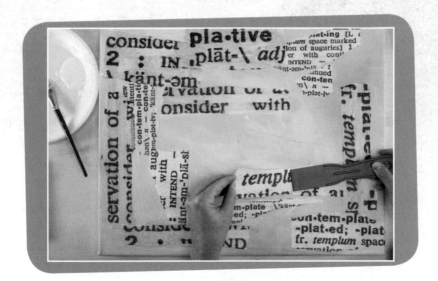

1 PREPARE THE BACKGROUND

Pour the acrylic paints onto the palette. Using a paintbrush, paint the canvas light blue, including all four sides. Allow the paint to dry.

Find the word *contemplate* in the dictionary; cut it out and manipulate it to be different sizes using a copier. You will need several copies.

Tear strips of the copies of the word *contemplate* and layer them onto the canvas using matte medium. Use the putty knife to smooth down the paper and eliminate bubbles.

2 COLLAGE THE BIRD IMAGE

Sketch a simple shape of a bird on a piece of bristol paper. Trace over the final design with the fine-tip black marker. Adhere double tack mounting film to the back of the paper.

Take a look at your bird sketch and decide which areas you want to define.

Layer the assorted papers onto the sketch, cutting where needed to fit. For those areas that are hard to fit (in this case, the bird's legs), add more paper than is needed and sketch the original lines onto the added paper. You will use these lines later to cut out the shape.

Use a clean paintbrush and matte medium to adhere the papers onto the sketch. Use the putty knife to smooth the papers.

3 LAYER TO CREATE THE BIRD'S TAIL

Continue layering paper on the sketch until you have completed the collage. Allow the matte medium to dry.

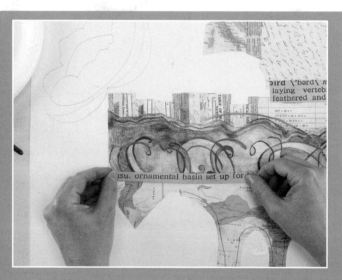

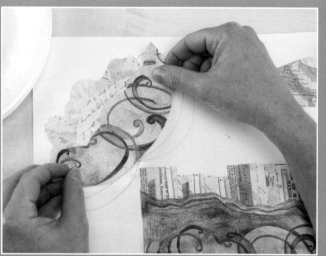

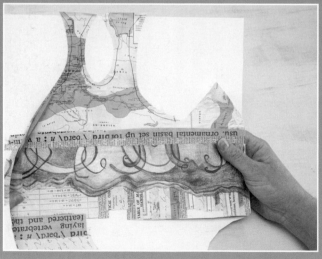

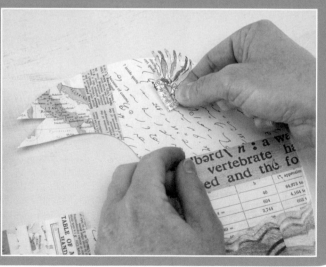

4 CUT OUT THE BIRD COLLAGE

Using scissors and a craft knife (for detailed areas), cut out the bird and tail.

5 EMBELLISH THE DETAILS

Enhance the bird by adding details. For example, I have selected a vintage postage stamp for the eye.

6 OUTLINE WITH A BLACK MARKER

Using a fine-tip black marker, outline the bird's shape and embellish within the bird's body. I drew lines and circles to define areas.

7 BLEND THE COLLAGE PAPER WITH PAINT

Using a mixture of the light blue acrylic paint and matte medium, brush a layer over the paper to help blend the paper with the background. Allow to dry.

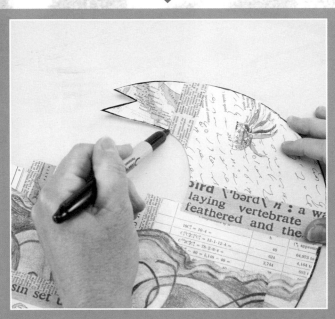

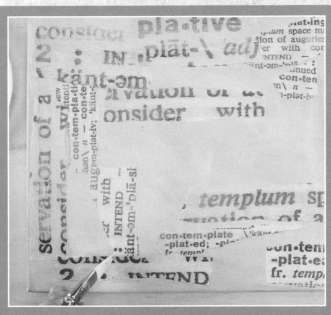

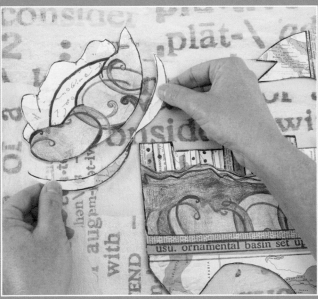

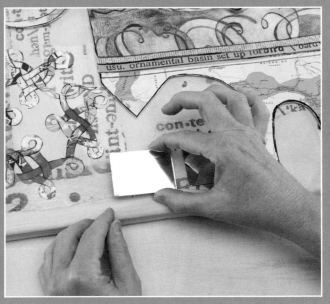

8 ADHERE THE BIRD TO THE BACKGROUND

Peel the backing off the double tack mounting film, position the bird on the canvas and adhere. Once you have completed all collage applications, flip the canvas over and apply weight to the back. Allow to set for an hour.

9 ADD A SYMBOL AND MIRRORS

Embellish the artwork with a symbol from your collage elements stash. Add the mirrors by brushing a coat of matte medium to the back of each mirror and gently pressing them onto the canvas. Once all the mirrors are applied, allow the art to set flat, undisturbed, for one hour or until it is completely dry.

visit createmixedmedia.com/crafty-birds for extras

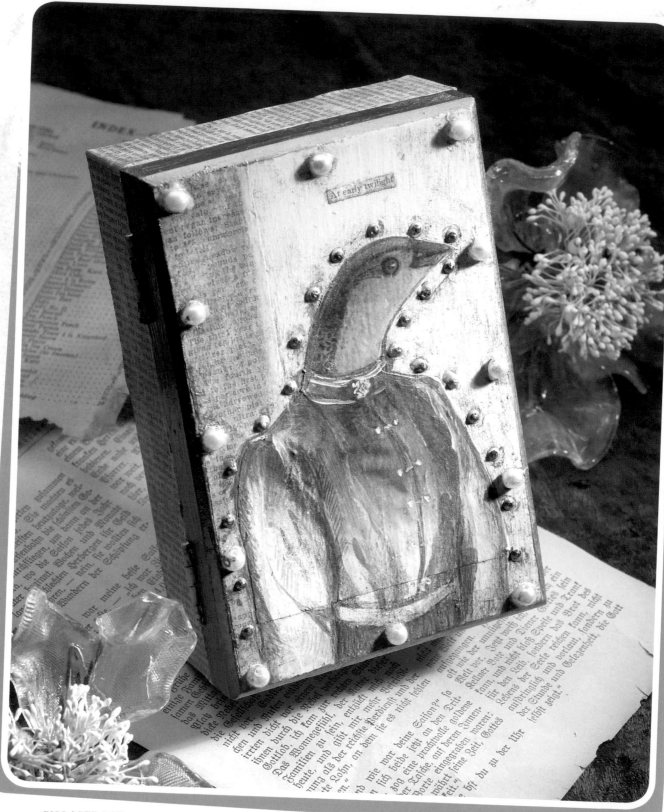

COLLAGED BOX
From Altered Curiosities *by Jane Ann Wynn*

There is something very intriguing and absurd about blending images of humans and animals together in different ways. This combination has piqued my interest since I was a child. It started with Beatrix Potter stories of little animals wearing clothes and talking. I fell in love with the idea of animal playmates. I used to look carefully at my cats and wait to hear them speak. I was convinced they would talk to me one day. (I still am.) So, when I started looking into the art and history of anthropomorphic images, I realized I had tapped into a very common subject, dating back to Egyptian times and continuing up through modern-day advertising. Pants on pandas, suits on seagulls and cats in hats—all humorous and delightful.

When I began to create my box, I knew I wanted to create a very dignified ladybird. I did a little research to help my efforts and discovered that there was an Egyptian god, Thoth, who was the god of the moon, magic and writing. He was usually depicted with the head of an ibis (bird) and the body of a man. I imagined his wife would have had a lovely jewelry box, so I decided to make a box in her honor. I took the image of a bird and one of an elegant lady, cut and pasted them together and created what I like to call Mrs. Thoth's Jewelry Box.

~ Jane

materials needed

Wood jewelry box

Ivory acrylic paint

Water

Paper towel

Gold metallic paint

Paintbrush

Patina solution and brush

Clear sealer

Paper images

Découpage medium

Pencil

Decorative paper

Drill and 3/16" (5mm) bit

Two-part epoxy

Craft stick

Pearls

Crystals

1 APPLY PATINA TO THE BOX

Paint the entire box with ivory paint. When it's dry, add gold metallic paint to the interior. Let dry, then brush a patina onto the interior as well. When the patina is dry, spray the interior with a clear sealer and then let that dry.

2 DÉCOUPAGE THE IMAGES

Begin découpaging the outside of the box with your chosen images. Here I decided to morph a bird's head on a woman's body.

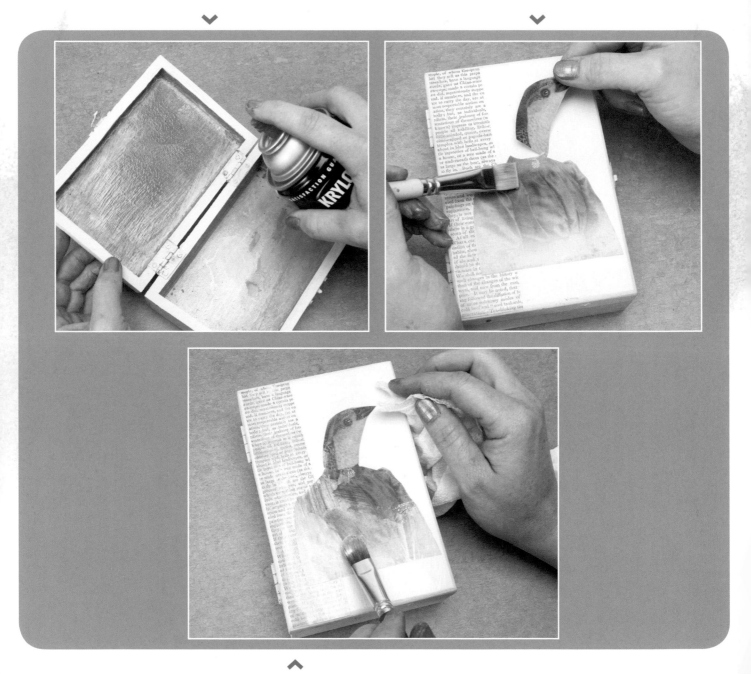

3 WHITE-WASH THE IMAGES

Lightly brush a thin coat of ivory paint (mix with a small amount of water) over all of the imagery, then use a paper towel to immediately wipe off the paint over the areas you most want to remain visible.

4 ADD SOME PENCIL
Redefine some areas with pencil. This can be as loose or as detailed as you like.

5 APPLY PAPER TO THE BOX SIDES
Add some paper around the sides of the box. When you get to the area of the clasp, just tear the paper around it.

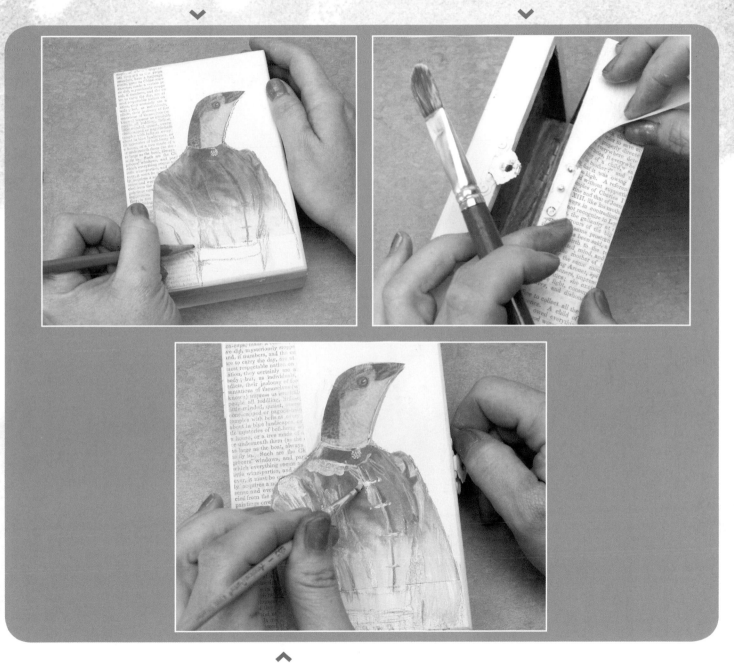

6 PAINT IN THE DETAILS
Now go back and add some more paint for depth, including adding details like these cute little buttons. Let dry.

7 CREATE DIVOTS

Carefully use a drill to make ³/₁₆" (5mm) divots for the pearls. You want to carve out a little cup, but you don't want to drill all of the way through the wood.

8 ADHERE THE PEARLS

Use epoxy to glue the pearls in the drilled divots. Let dry.

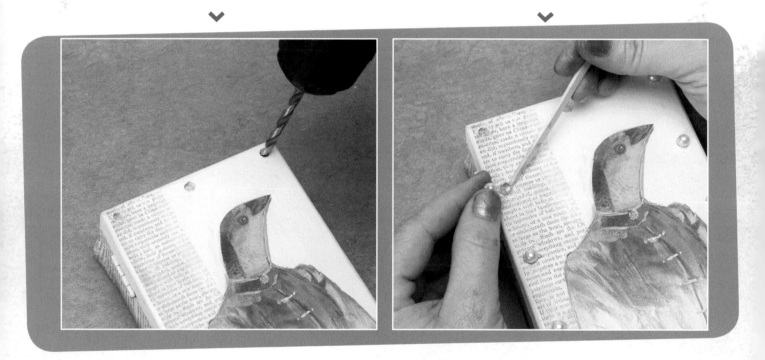

9 APPLY THE SPRAY SEALER

Cover the box with two coats of clear sealer, allowing drying time between coats.

10 ADD THE CRYSTALS AND FINAL TOUCHES

Using epoxy, adhere tiny crystals around the perimeter of the head, setting each crystal by pushing it into the epoxy and letting it ooze out around it a little bit. Give the "clean" white areas a little smudge with a dry paintbrush and gold paint before spraying the entire box with a final coat of sealer.

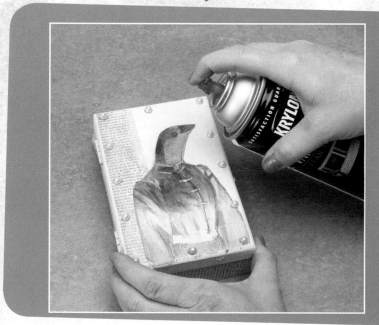

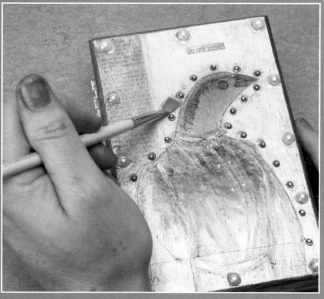

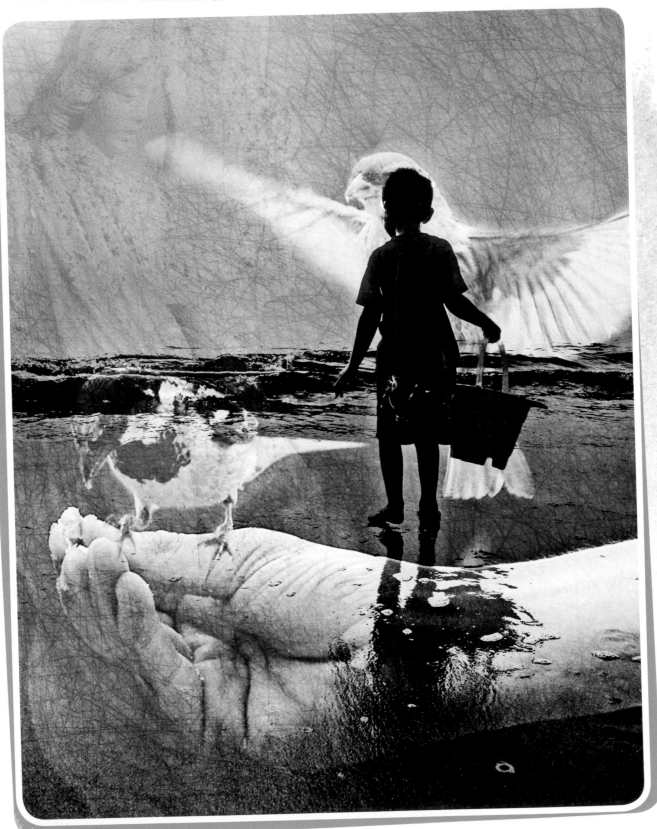

MY FLEDGLING: MERGED TRANSPARENT LAYERS
From DIGITAL EXPRESSIONS *by Susan Tuttle*

This past summer my son became very comfortable with the ocean, no longer needing to hold my hand, going in knee-deep instead of cautiously brushing his toes against the foamy shore. With my camera, I captured him heading off to play in the sea, utterly independent, with red bucket in hand. As I looked through the lens, I experienced a defining moment—I could see that this was the beginning of letting go as a parent. Thus, this piece is titled *My Fledgling*.

In this digital collage, I imposed a photo of birds, imagery of an angel statue and a texture photo over the original photo of my son. I played with their Opacity levels to achieve a variety of transparent effects. The bird eating from the human hand is symbolic of motherhood and nurturing one's child. The second bird, imposed over my son, is the fledgling, symbolic of independence and wholeness. The imagery of the angel represents my son's guardian angel, who watches over him at all times, even when I am not with him.

~ Susan

materials needed

DIGITAL MATERIALS

Subject photo: a small subject in a large background

Two additional photos: one will be more prominent than the other, and photos with dark or black backgrounds work best

Texture photo

SOURCES FOR PROJECT ARTWORK

Bird and angel photos: Lisa Solonynko (www.morguefile.com)

Texture: www.morguefile.com

TECHNICAL SKILLS

Duplicating a file

Adjusting Shadows/Highlights Moving a file into another

Resizing/rotating

Adjusting the Opacity of a layer

Merging layers/flattening an image

Feathering

Adjusting Color Curves

TOOLS:

Lasso Tool

Eraser Tool

TIP

See the TECHNICAL SKILLS AND TOOLS *sidebar at the end of this projects for quick and easy directions for working with the skills and tools listed above.*

1 ADJUST THE SHADOWS/HIGHLIGHTS ON SUBJECT PHOTO

Open the subject photo. A photo with a small subject set in a large background works best for this project. I chose a subject photo of my son on the beach. Duplicate the file (see sidebar, *Technical Skills and Tools*); this will be your working file. Play with shadow and highlight levels to give the photo some drama by going to the Shadows/Highlights menu (see sidebar, *Technical Skills and Tools*). I set my levels as follows: Lighten Shadows: 53%; Darken Highlights: 0%; Midtone Contrast: 100%.

2 OPEN AND ADJUST THE SECONDARY PHOTO

Open the more prominent additional photo and move it (see sidebar, *Technical Skills and Tools*) into the working file. Resize it (see sidebar, *Technical Skills and Tools*) as needed to fit the working file. Set the Opacity level (see sidebar, *Technical Skills and Tools*) of this new layer to about 50%.

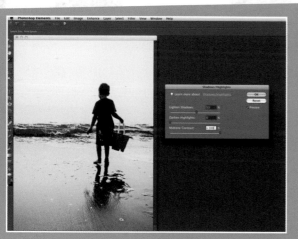

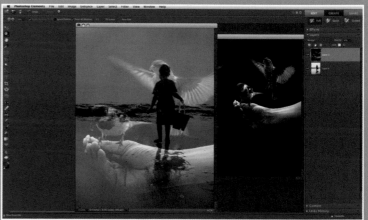

3 MERGE THE LAYERS AND ADJUST THE SHADOWS/HIGHLIGHTS

Merge the layers (see sidebar, *Technical Skills and Tools*). As needed, adjust the shadow and highlight levels. I felt my piece lacked intensity, so I adjusted the Shadows/Highlights to infuse it with a bit more electricity. Significantly increasing the contrast of the midtones helped me achieve this. I set the levels as follows: Lighten Shadows: 9%; Darken Highlights: 6%; Midtone Contrast: 100%.

4 SELECT AND MOVE THE OBJECT IN THE THIRD PHOTO

Open the remaining photo. A photo with a lot of contrast between the subject and background works best for this. Using the Magnetic Lasso Tool (see sidebar, *Technical Skills and Tools*), trace around the subject of the photo. Feather the edges (see sidebar, *Technical Skills and Tools*) of the selection with a Radius of 5 pixels. Move the selection to the working file and resize it to fit. Set the Opacity of this new layer to 13%.

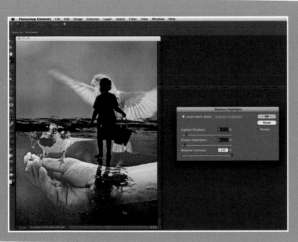

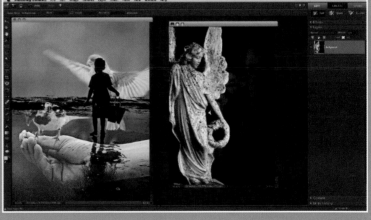

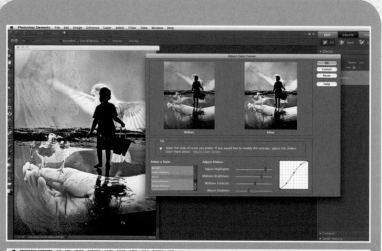

5 ADJUST THE COLOR CURVES AND HUE/SATURATION

Open the Color Curves menu (see sidebar, *Technical Skills and Tools*). Play with Shadows, Midtone Contrast, Midtone Brightness and Highlights by adjusting the sliders. Then, using the Magnetic Lasso Tool, select various areas of the working file and adjust the Hue/Saturation and Brightness/Contrast as desired.

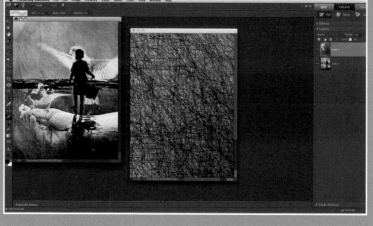

6 ADD THE TEXTURE PHOTO

Open the texture photo and move it into the working file. Adjust the size as necessary to fit. Set the blending mode of the texture layer to Overlay and adjust the Opacity to 36%. Use the Eraser Tool (set to an Opacity of 20%) to erase the part of the texture layer that covers up the subjects in the photos (see sidebar, *Technical Skills and Tools*). Here, I erased parts that covered up the angel statue. When the piece is complete, flatten the image and save the file.

ADJUSTING COLOR CURVES

ENHANCE>ADJUST COLOR>ADJUST COLOR CURVES
Use this command to adjust the tonal range of your imagery. You can adjust up to fourteen different points of an image's tonal range, from shadows to highlights, giving you more control than you get when using the BRIGHTNESS/CONTRAST menu.

ADJUSTING THE OPACITY OF A LAYER

You can adjust the OPACITY levels of a layer by clicking on the layer in the LAYERS PALETTE and moving the OPACITY slider located at the top of the LAYERS PALETTE. You can also adjust the OPACITY of various tools in their respective toolbars. Just move the slider to the left to increase transparency.

DUPLICATING A FILE

Going to FILE>DUPLICATE will make an exact copy of a file you have opened. If you are starting with a photo that will be your working file, it is a good idea to make a duplicate of it first.

FEATHERING

To soften or blur the edges of a selection you have made with one of the LASSO TOOLS, go to SELECT>FEATHER. You can set the FEATHER RADIUS as desired—the higher the number, the greater the feathering effect. Some of the details on the edge of the selection will be lost. You really notice the effect of this tool when you move the selection to your desired spot.

MERGING LAYERS/FLATTENING AN IMAGE

To organize and simplify working files, you can combine multiple layers, making them into one layer. (Just be sure you will not want to manipulate the layers later on.) To do this, select the layers you want to merge in your LAYERS PALETTE by holding down the Command key (the Ctrl key on a PC). At the same time, click on the layers you want to merge. They will be highlighted once you click on them. Release the Command key when you have finished selecting the layers. Then, go to LAYER>MERGE VISIBLE to merge them. Keep in mind that once layers are merged, they cannot be changed (only added to). Flattening an image (LAYER>FLATTEN IMAGE) merges all layers, and also turns transparent areas to white.

MOVING A FILE INTO ANOTHER FILE

The MOVE TOOL, located at the top of the TOOLS PALETTE, will be one of the most used. Click on the tool prior to selecting and moving layers as well as resizing and rotating. You can also use this tool to move one file of imagery to another.

RESIZING/ROTATING

To resize a layer, select the MOVE TOOL, then click on the layer (in your working file) and drag on the hollow squares located at the edges and corners of the image. Press the Shift key while resizing your object to maintain its proportions.

Rotating and flipping options are located at IMAGE>ROTATE. The first six choices allow you to rotate or flip the entire working file. The next six allow you to rotate or flip a layer.

You can free-rotate a layer in two similar ways: (1) select the layer then click on the hollow circle at the bottom, center of the layer and drag to rotate; (2) select the layer, place your cursor on top of one of the hollow squares until it becomes an arched arrow and then drag to rotate. Make sure the MOVE TOOL is selected before rotating. To rotate a layer a specific amount of degrees and in a specific direction, go to IMAGE>ROTATE.

SHADOWS/HIGHLIGHTS

ENHANCE>ADJUST LIGHTING>SHADOWS/HIGHLIGHTS
This feature allows you to darken or lighten shadows and highlights, and increase or reduce the contrast of middle tones.

USING THE ERASER TOOL

I use this tool to clean up the edges of selections and other undesirable areas. For best results, zoom in on an area (using the ZOOM TOOL). If you select a background color and use the eraser, it will apply the background color you selected. If you have not selected a background color, it will make the pixels you erase white (or transparent, if your file is transparent).

USING THE LASSO TOOL

The LASSO TOOL allows you to make different types of selections. The basic LASSO TOOL allows you to make a free-form selection. If you need more control when making your selection, I recommend using one of the other LASSO TOOLS.

The MAGNETIC LASSO TOOL works well when selecting objects with fine details, especially if the object contrasts with the background. Trace around the object in its entirety, ending up exactly where you started (you'll see a small transparent circle) in order to select it. If you miss a part, just press the Shift key and trace around the area that you want to add to the existing selection. Using the MOVE TOOL, you can then click and drag a selection.

Use the POLYGONAL LASSO TOOL when selecting areas with straight lines and angles.

›› ROYAL BIRD ‹‹

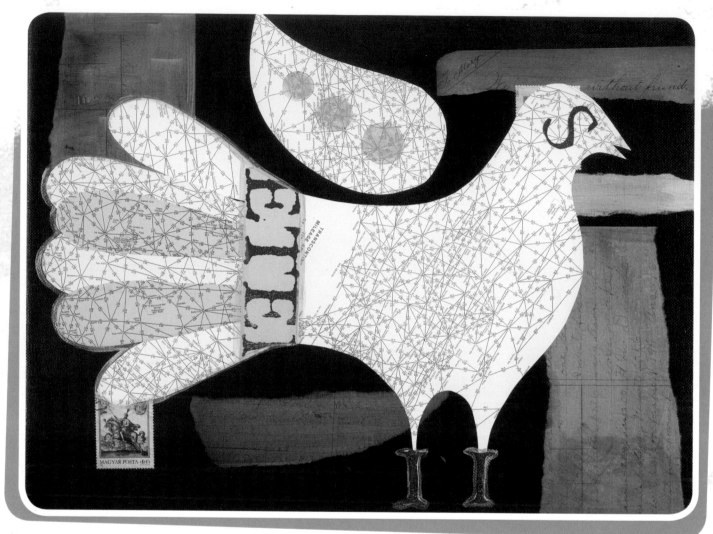

ROYAL BIRD
From COLLAGE PLAYGROUND *by Kimberly Santiago*

Peacocks are such regal birds with their beautiful colors and spanning feathers. I wanted to create a piece of art that was similar but more understated than *Contemplate Bird*. I found a map with intricate graphics to use for my bird and used pastel paper to introduce color. Bringing in metallic gold pushed the bird into a royal state. What colors, images or textures emphasize royalty to you? Look at the shape of your bird; how can you express elegance?

~ Kimberly

materials needed

Acrylic paint in black, burnt, sienna, burnt umber, gold metallic

Matte medium

Palette

Gallery wrapped canvas, 12" × 16" (30cm × 41cm)

Paintbrushes

Torn pieces of vintage letters

Putty knife

Vintage postage stamps, 2

Pastel paper in assorted colors

Vintage maps

Scissors

Color copier

Pencil

Sketch paper

Text (for eye, legs and band)

Craft knife

Cutting mat

Circle template

60

1 LAYER PAPER ON THE CANVAS

Pour the acrylic paints and matte medium onto the palette. Paint the canvas black, including all four sides. Set aside to dry. Once the canvas has dried, tear strips of paper and begin layering the paper using matte medium. Use the putty knife to smooth down the paper and eliminate bubbles. Add vintage stamps as embellishments. To help blend the starkness of the paper and stamps onto the black background, add a small amount of matte medium to a neutral-colored paint (I used burnt umber and burnt sienna) and brush over the entire canvas.

2 ADD THE BIRD SHAPE

Cut three sheets of yellow pastel paper, one sheet of tan, and one sheet of buff to 8½" × 11" (22cm × 28cm). Make copies of the map onto these sheets of paper.

Sketch a simple shape of a bird and use this sketch to make a template. Use the template and trace the bird's body and wing onto the yellow paper, and cut out. With the remaining papers, trace and cut out the feathers, making the feathers slightly different shapes and sizes. You will need approximately four feathers from each color of paper.

Using the matte medium and a clean brush, assemble the bird on the background. It is important you use a clean paintbrush because you do not want to get paint on the bird. When adding the feathers, alternate different colors and shapes.

3 ADD THE LETTERS AND TEXT

With the copier, enlarge a band of text and letters for the bird's legs and eye, and copy them onto a sheet of tan pastel paper. Cut out the band. The size should cover where the feathers meet the bird's body. Cut out the letters for the legs and eye.

Use the matte medium to adhere the band of text over the area where the bird's body and feathers meet, hiding the seam lines. Adhere the individual letters to their appropriate spots. If needed, use the blade of the craft knife to gently position the letters. If you desire, continue to embellish with more text and letters.

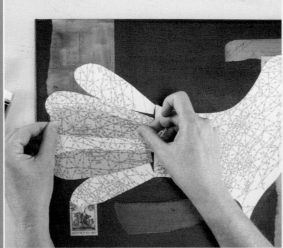

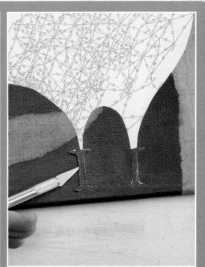

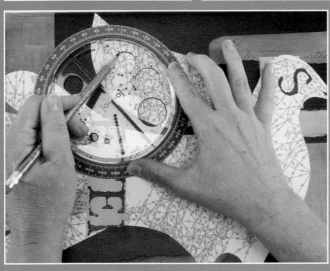

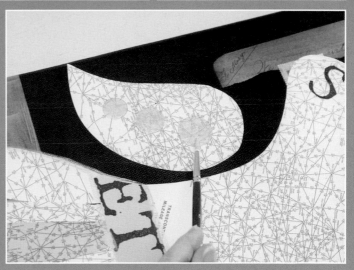

4 DRAW THE CIRCLES

On the bird's wing, use a circle template to trace three circles (each one a different size).

5 EMBELLISH WITH METALLIC PAINT

Enhance the bird with gold metallic paint. Fill in the circles on the wing and outline the feathers and legs.

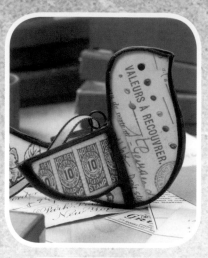

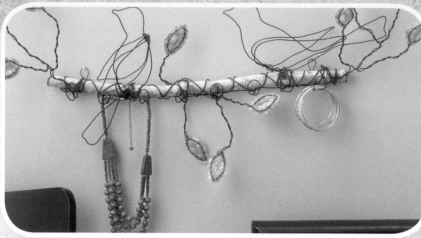

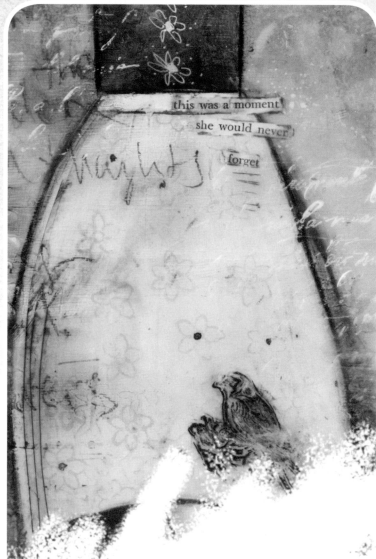

this was a moment
she would never
forget

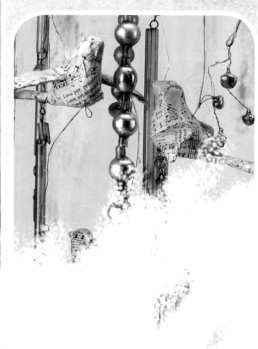

MIXED MEDIA BIRDS

BIRDCAGE MEMORIES

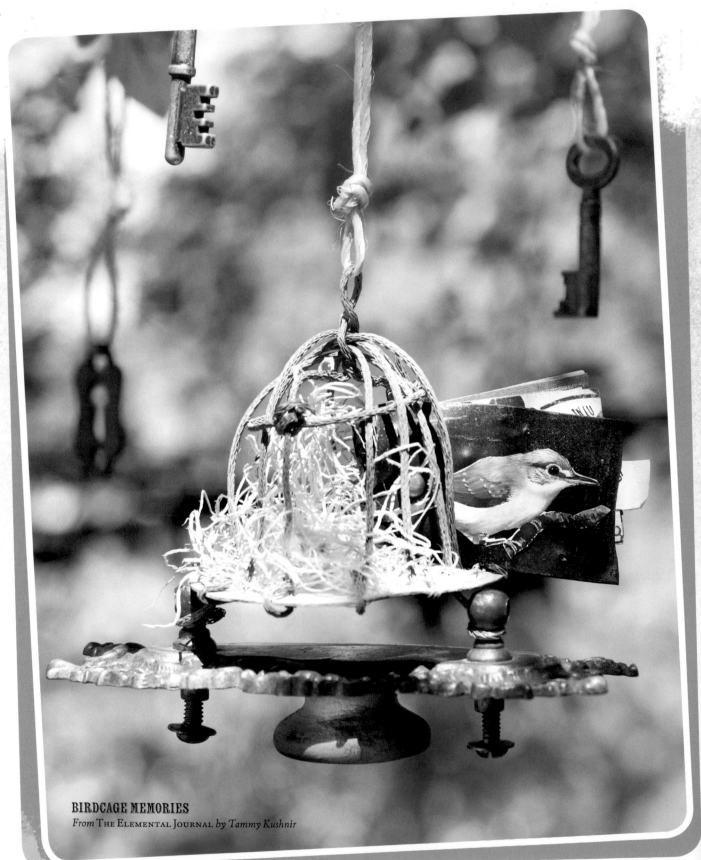

BIRDCAGE MEMORIES
From The Elemental Journal by Tammy Kushnir

I love birdcages. They hold a fascinating symbolism to me. In this case, the birdcage was created out of galvanized wire and vintage hardware. We all make our own cages, so the saying goes, and this time the saying is very literal. But what to put in the cage? Now that is the question, and my answer is journal cards!

~ Tammy

materials needed

Bookbinder's board	Patterned paper
Brad	Small doorknob or circular wooden finding
Clothing tag or piece of sturdy fabric or soft cardboard	Soft shredded wood
Collage images, including bird image	Straight pin
Colored pencils	Thin scrap metal
Feathers	White and gold acrylic paints
Fine-point marker	Awl
Galvanized metal wire	Craft glue
Miniature fabric heart	Heavy-duty scissors
Newsprint paper	Paintbrush
Ornate brass plate	Scissors
	Wood or metal glue

1 CUT OUT AND PAINT A CIRCLE

From a clothing tag, cut out a circle with a 3" (8cm) diameter. Paint the circle with white and gold acrylic paints. Punch 12 holes evenly around the edge of the circle using an awl.

2 CUT THE WIRE

With heavy-duty scissors, cut seven pieces of galvanized metal wire, each measuring 7" (18cm). Paint the pieces with gold acrylic paint.

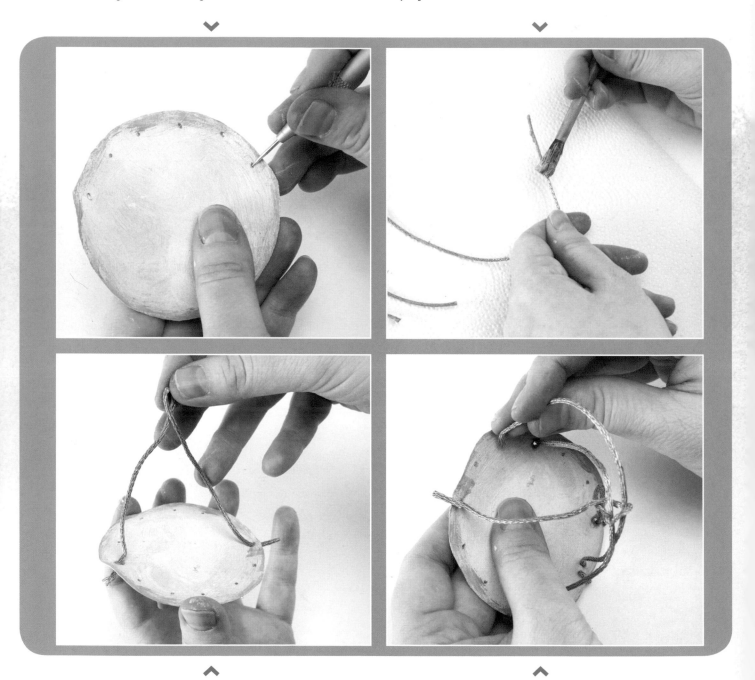

3 THREAD THE WIRE INTO THE CIRCLE

After the wire pieces are dry, thread one piece through a hole in the cage base. Form a U-shape over the base and thread the other end of the wire in the hole directly across from the first hole. Twist the wire once at the center, creating a loop. (Do not secure the wire ends on this first piece, as they will be needed later.)

4 REPEAT STEP 3 WITH FIVE MORE WIRE PIECES

As you bring each wire across the circle, thread it through the loop made in the first wire. For each of these wires, bend the ends up and around the edge of the circle to secure them. When the basic form is finished and all the holes have been used, wrap the remaining piece of wire around the top portion of the birdcage, weaving it through the bars and twisting to secure it.

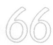

5 ADD EPHEMERA INTO THE BIRDCAGE
Glue soft shredded wood and tiny feathers to the base of the cage.

6 PREPARE THE BRASS PLATE
Glue a doorknob or a circular wooden finding to the base of an ornate brass plate using wood or metal glue.

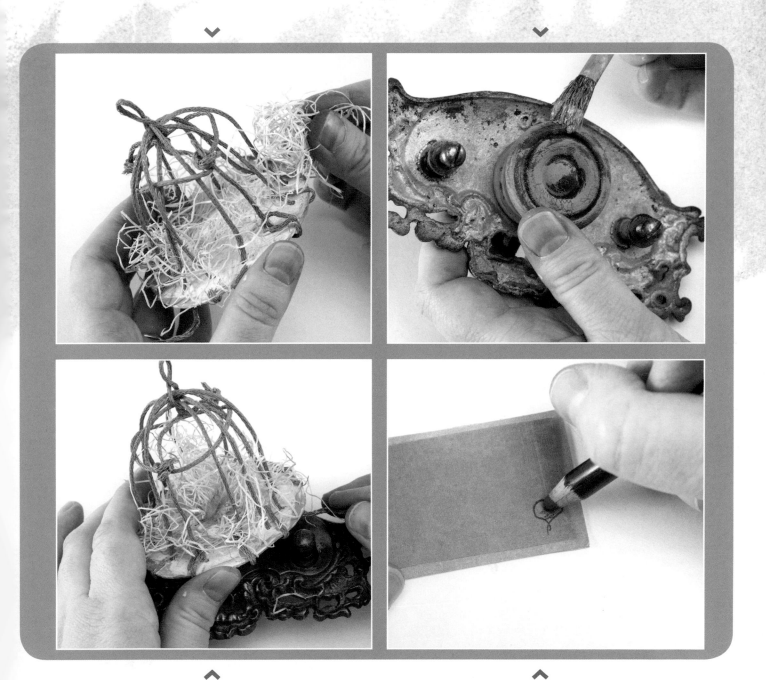

7 ATTACH THE BIRDCAGE TO THE BRASS PLATE
Using the unsecured wire ends from the first piece of birdcage wire, secure the cage to the knobs on the brass plate.

8 PREPARE THE JOURNAL
Cut the desired number of pages for the journal from book-binder's board, each measuring 2" × 3" (5cm × 8cm). Cut and glue pieces of patterned paper to both sides of each page. Add doodles with colored pencils or glue collage images to the pages as desired.

9 PUNCH HOLES IN THE JOURNAL PAGES
Using an awl, poke a hole through the left side of each page.

10 EMBELLISH THE FIRST PAGE OF THE JOURNAL
Cut a strip of newsprint paper and write the word *memories* on it. Attach this strip, along with a miniature fabric heart, to the first page with a straight pin.

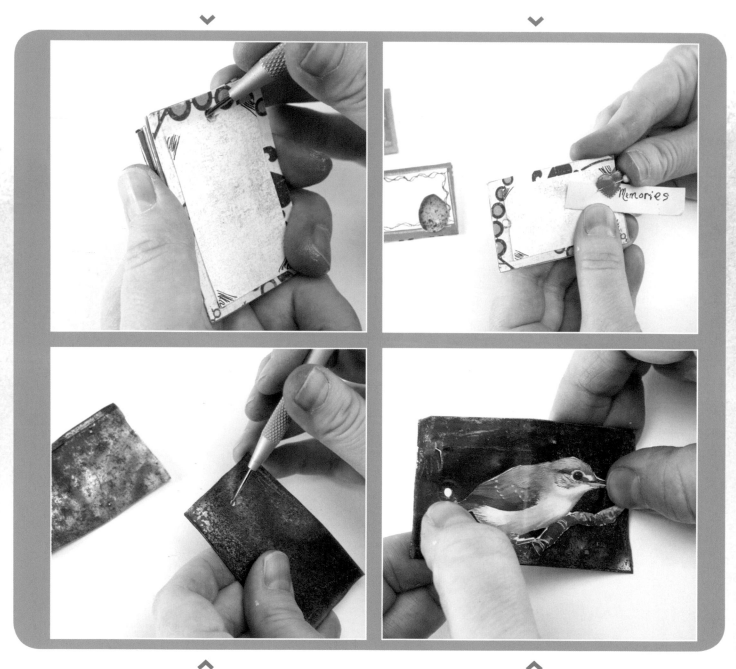

11 CUT THE METAL FOR THE JOURNAL COVER
Cut two pieces of thin scrap metal, each measuring 2" × 3" (5cm × 8cm), for the covers. Using an awl, poke a hole through the left side of each cover.

12 CHOOSE AND ADD THE COVER IMAGE
Glue an image of a bird to the front cover.

13 JOIN ALL PARTS OF THE JOURNAL

Sandwich the pages between the front and back covers. Attach the covers and pages by pushing a large brad through the holes in the left-hand side.

14 INSERT THE JOURNAL INTO THE BIRDCAGE

Slide the book in between the bars of the cage to secure it.

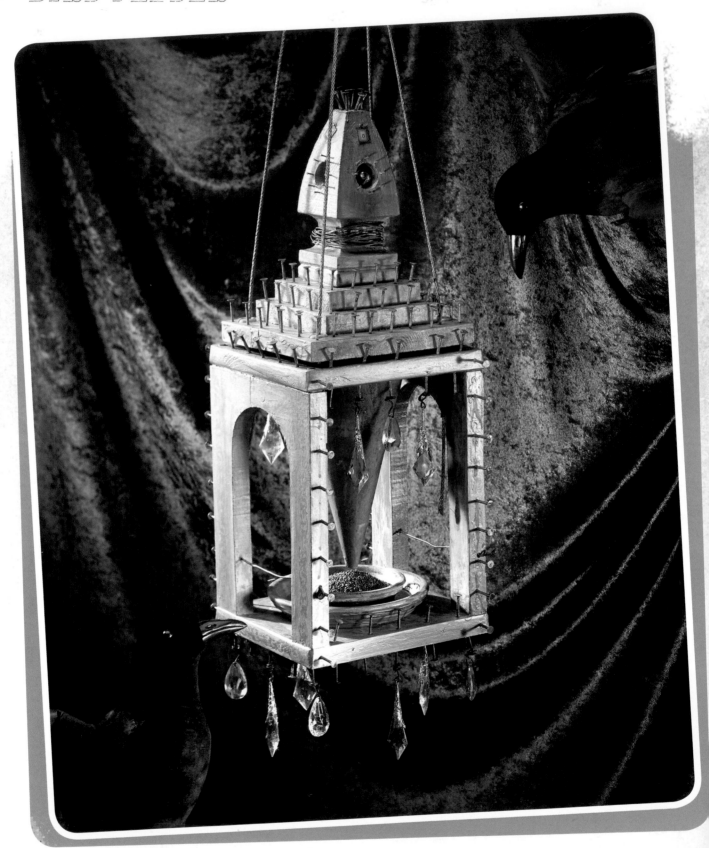

BIRD FEEDER
From Altered Curiosities *by Jane Ann Wynn*

I was very lucky to grow up with my grandmother, who lived with our family. She taught me nursery rhymes and spent hours reading to me. She would tell me to look for the bird in every picture. She loved birds and thought it took a special talent to find them. We would pore through images in art books, looking and searching. In the earliest spring before the ground had time to fully thaw, we would stand guard at the window, waiting to see the season's first robin. I think she liked to keep me busy and quiet with this little game. Even now I think of her whenever I see birds. They are such a charming reminder of her.

Now I take care of the little feathered creatures who live near me. Over the years I have had many kinds of bird feeders and birdhouses. Recently I began to make them into outdoor sculptures as a sort of tribute. This is an example of a fancy chandelier-inspired piece.

~ Jane

materials needed

- Fence post cap
- Square pieces of wood:
 - 7" (18cm), 3 pieces
 - 5" (13cm)
 - 4" (10cm)
- Drill and 5/16" (8mm) bit and 3/4" (19mm) routing bit
- Rectangles of wood, 7" × 9 1/2" (18cm × 24cm), 2 pieces
- Gold metallic paint and brush
- Patina solution and brush

- Ivory paint
- Epoxy
- Bent needle tool
- Head pins
- Pearl
- Needle-nose pliers
- Scroll rubber stamp
- Gold pigment ink pad
- Brass nails, small and medium
- Hammer

- Metal letter charms to spell "bird"
- Brass floral wire
- Propane torch
- Cemetery cone
- Clothesline wire
- Jigsaw
- Terra-cotta saucer
- Clear sealer
- Assorted crystals

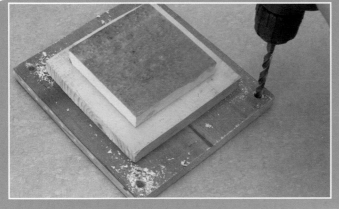

1 STACK AND DRILL THE BASE
Using epoxy, stack the 4" (10cm) and 5" (13cm) squares of wood onto one 7" (18cm) square. When cured, drill a 5/16" (8mm) hole into each corner.

2 DRILL HOLES IN THE CAP
Paint the fence cap with gold metallic paint and then add a patina. Using a 3/4" (19mm) routing bit, drill a hole into each of the four sides, slightly lower than center.

3 ADD A PEARL ON THE WIRE

Use a bent needle tool to make a starter hole at the top of the first hole. Thread a pearl on a head pin and use pliers to push the pin up into the hole. Push it in far enough so the pearl hangs where you want it.

4 STAMP OVER THE PATINA

Using a gold pigment ink pad, stamp the scroll pattern onto the bottom edge of the fence post cap.

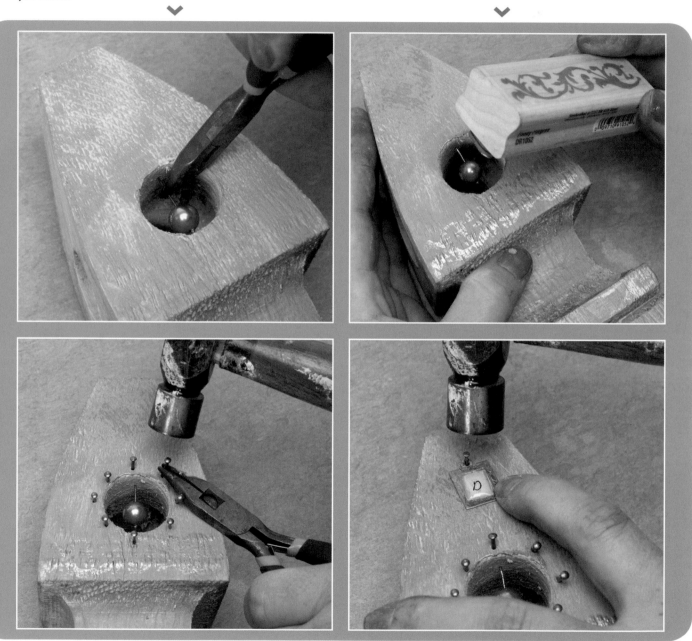

5 SET THE BRASS NAILS

Use a needle tool to punch twelve holes (in a clock formation) along the perimeter of the hole. Set tiny brass nails into the holes with a hammer.

6 ADD THE EMBELLISHMENT LETTERS

With a brass nail, hammer the letter *D* to the top of the fence post cap.

7 ASSEMBLE THE WOOD PIECES

Repeat steps 3–6 for the remaining three sides. Hammer several medium nails into the top of the cap and set aside. Paint and patina the stacked wood from step 1 and screw the cap to the center. Hammer medium nails along the perimeter of each square. Wrap brass wire around the base of the cap.

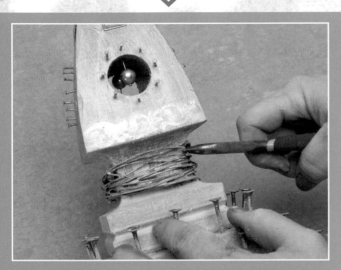

8 PREPARE THE METAL CONE

Burn the paint off of the cemetery cone, using a propane torch. Be sure to work in a room with adequate ventilation and, preferably, wear a mask. The cone will be used to hold the birdseed.

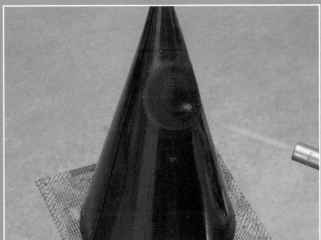

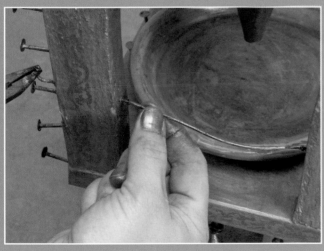

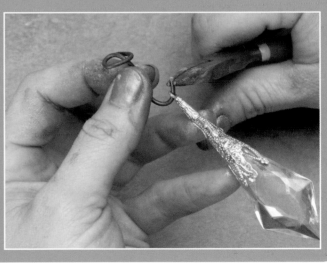

9 ADD THE WIRE PERCHES

For the base, trace the cone onto the center of one 7" (18cm) square of wood. Cut a hole in the center, big enough to get a jigsaw blade into. Then, cut from the center to the traced line, and then around the circle to cut it out. Cut one 4" × 8½" (10cm × 22cm) arch shape out of each of the two rectangular pieces in the same way. Paint a terra-cotta saucer with ivory paint, then gold metallic paint and patina. When it's dry, seal it with clear sealer. Glue the wood for the base together as shown and paint and patina to match the cap. Set the cap piece onto the base and, using the holes in the corner as a guide, drill corresponding holes in the base. Hammer in medium nails to the outsides of the rectangles and along the top and the bottom of the bottom of the base. Drill holes through the sides of the rectangle pieces, about 2" (5cm) from the bottom, then string a length of clothesline wire through the holes and across the arch opening. Curl the ends up to secure.

10 FINISH OFF WITH CRYSTALS

Using clothesline wire, attach crystals to the nails at the bottom of the base and some along the top. Fill the feeder, place the saucer in the bottom and you're good to go!

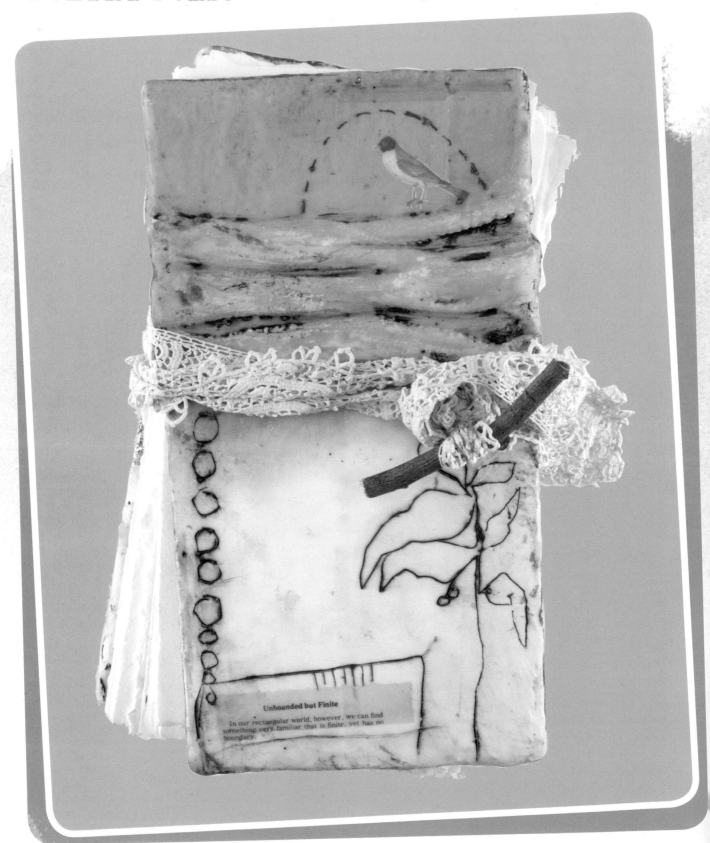

POETRY FOLIO
From PLASTER STUDIO *by Stephanie Lee*

Traditional bookbinding can be intimidating to the novice book-maker. It can discourage some curious, but unsure, creative types from diving into the diversity of book arts.

This project is perfect for someone who wants to start creating book-like pieces without any knowledge of or patience for—that's me, by the way—traditional stitching techniques. All you are creating in this project is a front cover, a back cover and a stack of whatever you want to tie between the two. Feel free to add fabric, vintage ephemera elements, photos, original art or poetry between the pages. To bind the stack together, I just used a piece of scrap lace trim with a stick tied to one end. I wrapped the other end of the lace around the stick to secure it and, voilà, a beautiful stack of art!

~ Stephanie

materials needed

Plaster gauze

Scissors

Tub of warm water

Corrugated cardboard, 2 same-size pieces

Acrylic paint, assorted colors (including white and burnt umber)

Paintbrushes

Damp rag

Collage elements

Acrylic gel medium

Encaustic medium, craft brush, hot pot

Heat gun

Scribe or carving tool

Fabric strip, ribbon or trim

Twig (optional)

Paper for interior pages

1 CUT AND DIP THE GAUZE PIECES

Cut a stack of large gauze pieces. Begin dipping them in water and laying them on one of the cardboard pieces.

2 LAYER THE GAUZE ON THE CARDBOARD AND WRAP

Layer on some pieces so the gauze extends over the edges of the cardboard and wrap the gauze pieces around to the back. At the corners, first fold the plaster gauze over and onto the cardboard. Then crease and fold it down onto the face of the cardboard. Continue adding gauze until the entire piece of cardboard is covered in two to three layers or to the desired thickness.

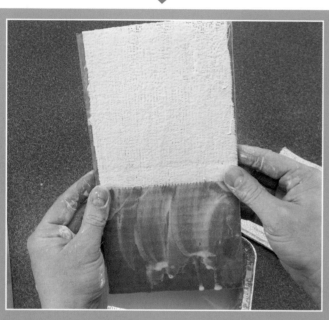

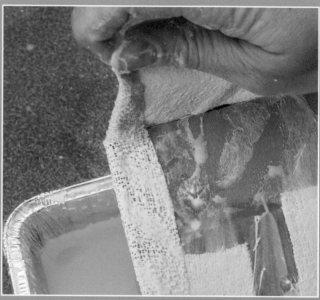

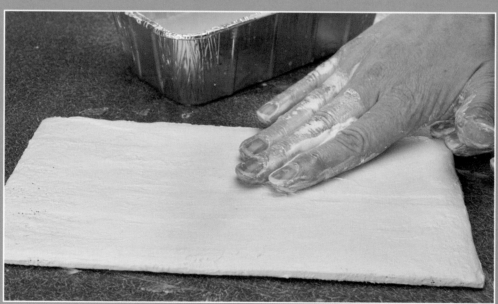

3 SMOOTH THE GAUZE

Use your fingers to smooth out the gauze as it begins to harden.

4 REPEAT STEPS FOR THE OTHER PIECE OF CARDBOARD.

Then cut a strip of gauze slightly wider than the width of your cardboard piece. Dip it in the water and then gently twist it and lay it on the face of one of the cardboard pieces.

5 ARRANGE THE TWISTED GAUZE LAYER

Spread the ends of the twisted piece and wrap them around the back of the cardboard piece. Blend them into the existing gauze.

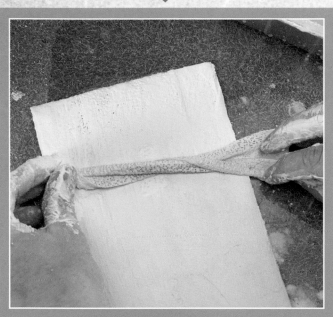

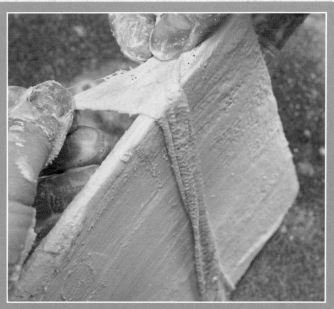

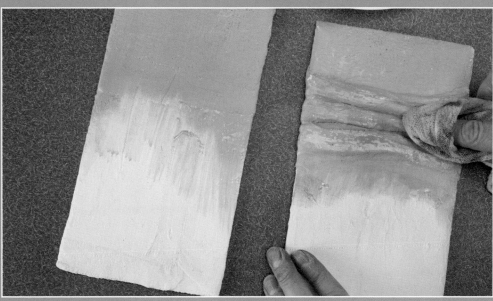

6 DRY AND PAINT AS DESIRED

Use your fingers to mold and smooth down the twisted plaster strips as desired. Repeat for a couple more twisted pieces and let them dry. Paint half of the cardboard pieces on what will be the outside covers. I'm using green and white. If desired, blend and soften the paint with a damp rag. Remove some paint from the high points on the gauze.

7 PAINT THE COVERS WITH WHITE PAINT

Paint the other ends of the covers and the back with white paint. (It may seem redundant to paint over the white plaster, but it's an important step because we'll be using encaustic medium later, and encaustic reacts differently with paint than it does with raw plaster.) With a damp rag, blend the area where the white and green paints meet. Allow the covers to dry.

8 EMBELLISH THE COVER

Gather the desired collage elements. Using gel medium, apply the collage pieces to the surface as desired. I used my fingers to apply the medium, but you can use a paintbrush. Allow the gel medium to dry.

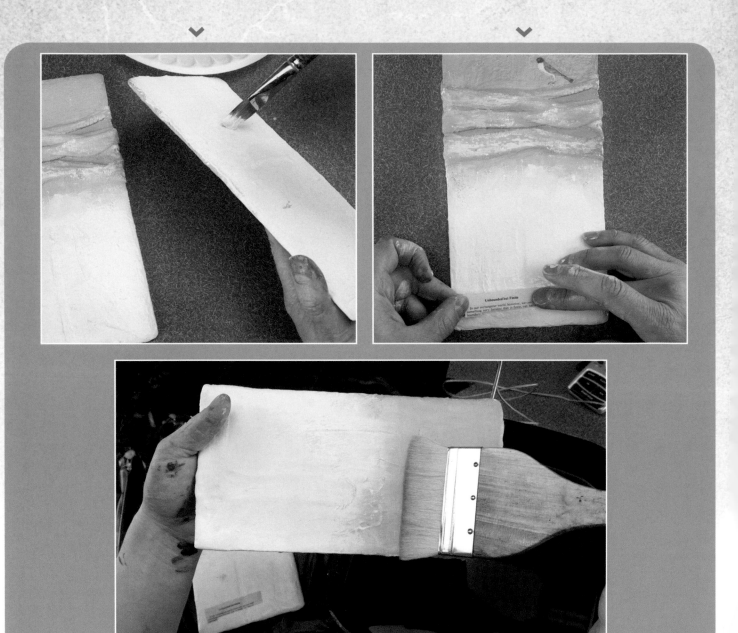

9 SEAL THE COVERS WITH ENCAUSTIC MEDIUM

To seal the covers, use a craft brush (or dedicated encaustic brush) to brush heated encaustic medium over the surface of each piece.

10 FUSE THE WAX
Use a heat gun to evenly fuse the wax into the painted plaster. Let the wax cool.

11 CARVE TEXTURE INTO THE WAX
Using a scribe or carving tool, create texture or draw simple shapes into the cooled wax. Paint over the covers with burnt umber paint. Use a wet rag to wipe the paint from the surface, leaving paint only in the incised crevices.

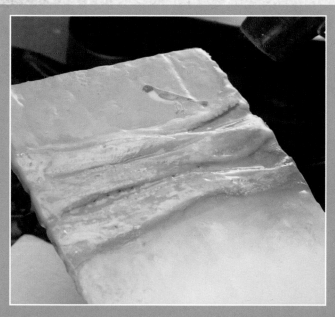

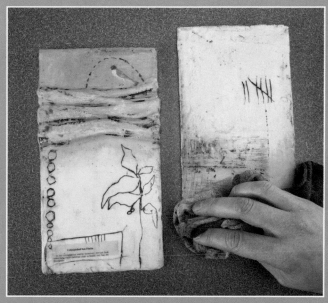

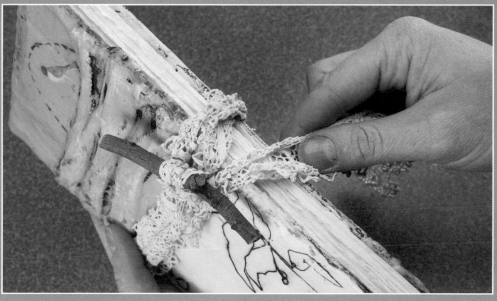

12 ASSEMBLE THE FOLIO AND TIE IT SHUT
To make the book, cut or tear paper to a size just a bit smaller than the covers. Assemble the pages, placing a cover on each side of the stack. Use a sturdy piece of fabric or trim to wrap the folio shut. There is no need to attach the fabric in any manner other than wrapping. I used a twig as a decorative element and tied the trim around it.

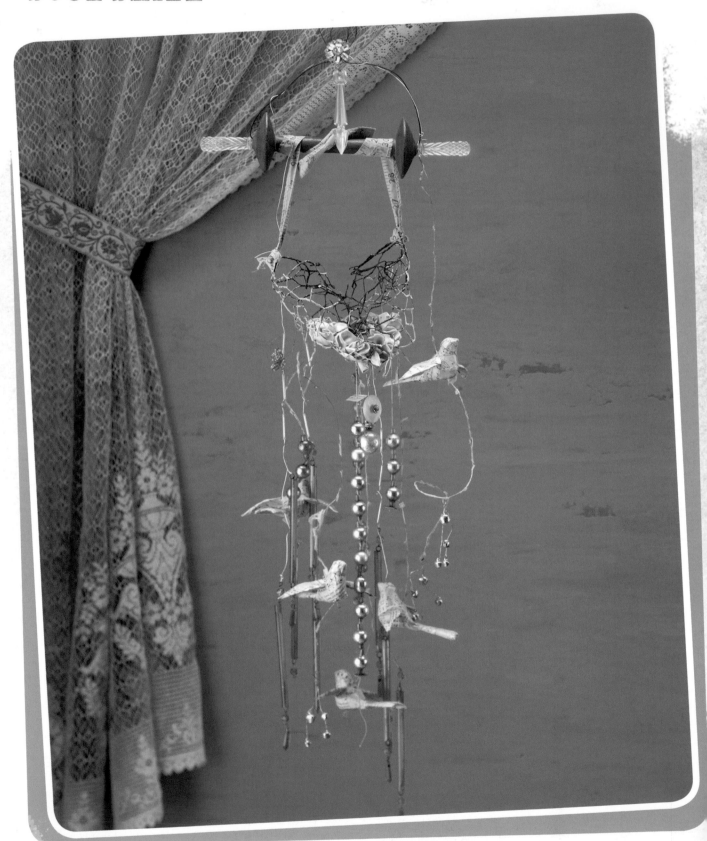

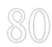

SOUL SHINE
From OBJECTS OF REFLECTION *by Annie Lockhart*

I quickly became friends with this piece before it was ever put together. I just love each of the elements in it so much. One of my vintage metal parlor baskets literally fell apart, and when it did I rescued all of the pieces, knowing that I'd use them in something. The rusty chicken wire was somewhat short and oblong. It was in the center of the basket to hold the flowers in place way back when, but when I folded it in half, it resembled a heart. Well, that was all it took for me to jump on this one. I saw the heart of the home, knowing that I'd add some type of nest, sheltered within the open heart. I didn't want to use an actual nest, although I could've. I waited for the right inspiration to strike. It was some time before I found the perfect nest for this one.

I spotted an antique satin wedding hairpiece in a case at a local antique mall, and yes, I paid too much for it. After I purchased it, I didn't think about it for a while, but, once I did envision it inside the harsh contrast of the rusty chicken-wire heart, it was a keeper and would make the nest I'd been searching for.

I saw it as a mobile; then came the thoughts of how I would put it all together and what I would still keep my eyes peeled for. It wasn't long before the old spool made its way into this. From there, I découpaged the plastic bird light covers with old hymnal pages and suspended them with papered wire from a vintage Japanese lantern, another one of those great finds that will one day be all gone! Gorgeous amber chandelier prisms keep the little birds company, along with some vintage mercury garland with its little cardboard squares keeping the birds from falling off. When something that good is happening all on its own, I don't mess with it. There is no amount of altering to reproduce that charm.

This is a good time to tell you that I use a lot of Christmas ornaments and decorations, mostly in their "as-found" condition. Sometimes I will alter them. The tiny silver bells are new, another Christmas-department find at the local craft store. To finish off the hanging elements of this piece, I simply added more textures with the vintage cloth measuring tape and some silver jewelry wire to secure it better. Once I threaded the heavy-gauged black wire through the spool and looped it up and around to make the actual hanger, it was just a matter of adding some adornments to finish the piece off. So . . . a rhinestone button to dress up the peak of the hanger and a funky plastic prism dangling down from it seemed to make it complete, until I spotted some plastic, equally funky corn-on-the-cob holders to finish off the sides of the wooden spool. It's fun to add these unusual finds, to hear people say, "What's that?"

This piece is also a good example of the use of repetition. Sometimes multiplying just a few elements goes a long way and truly helps send a message.

~ Annie

EDITOR'S NOTE

Soul Shine *is certainly a different sort of project demonstration than many of the others in this book—it's really meant to be more inspiring than a straight, "here's how-to and here's what you'll need" sort of tutorial. And anyway, is there a chance that you could track down the exact materials Annie Lockhart uses here? Unlikely at best. So I hope Annie's flair for the unique might incite you to take a look around and see your environment differently. What about that chain of broken Christmas tree bead garland? What might you be able to do with that? And what about that old spool? Should you perhaps hold onto it? And didn't you save that old rhinestone bead you found? Now where did you put it? The possibilities are—truly—endless.*

materials/legend

1. Plastic prism—funky
2. Wooden spool—simple order
3. Corncob holders—hold on
4. Cloth tape measure—measure of time
5. Wire heart—lovely opposites
6. Satin headdress—circle of love
7. Beaded silver flowers—patient beauty

8. Tiny silver wire—got your back/support
9. Rhinestone button—sparkle
10. Silver mercury garland—connection
11. Tiny silver bells—sweet sounds
12. Songbirds—community
13. Gold prisms—soul shine

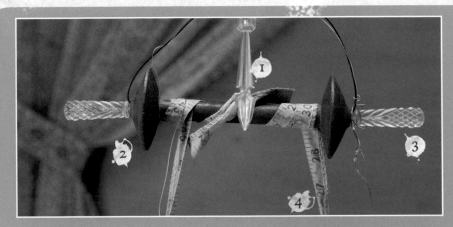

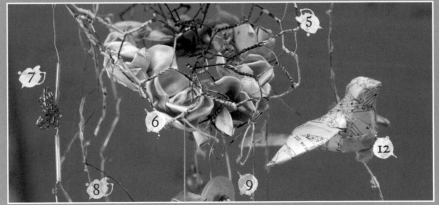

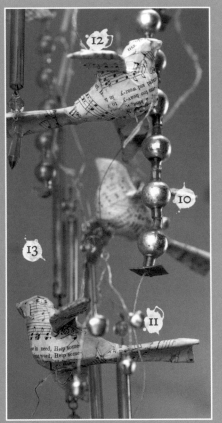

TIPS

Make this a reflective assignment: Consider each of the objects you use and jot down your thoughts about what each might represent to you. Your reflection can be a simple word or two, like what Annie has done with her materials list/legend, above, or, with more detail, it might make a nice journal entry.

Whenever you're constructing a mobile or any hanging artwork, make sure to use a heavy wire. Along with the cloth measuring tape, Annie added a thin silver wire to help secure it. Just remember to test the weight of the items that the hanger is holding, and keep the weight at the bottom lighter.

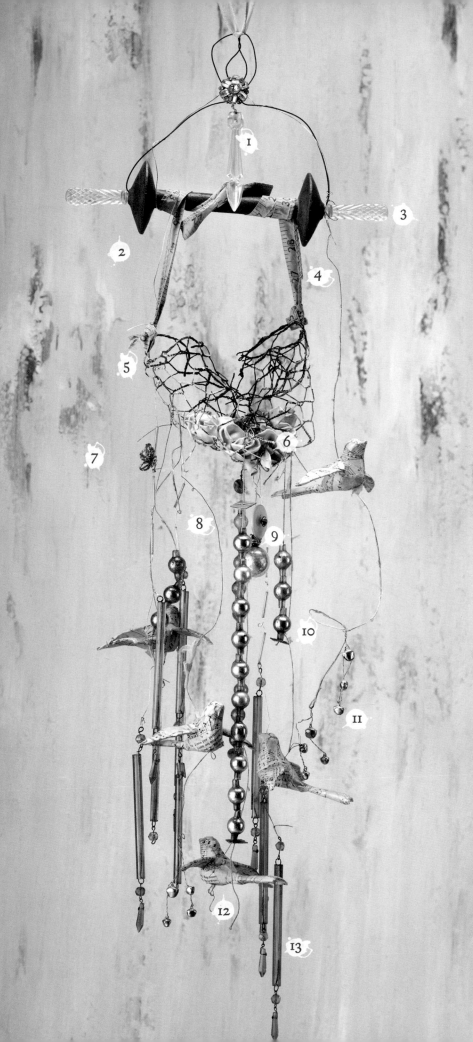

TWEET

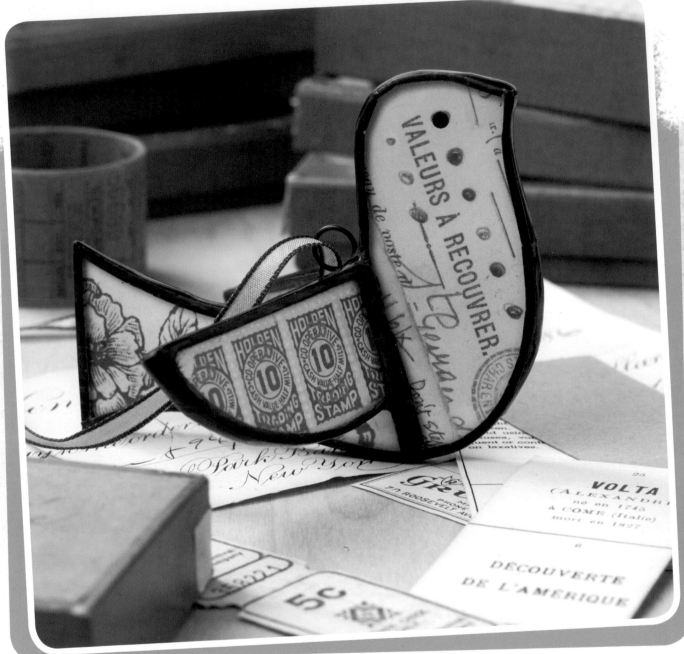

TWEET
From SOLDER TECHNIQUE STUDIO *by Giuseppina "Josie" Cirincione*

EDITOR'S NOTE

This project, Tweet, by Josie Cirincione, is likely the most complex and detailed project in this book. We have tried to cover all the bases here by including safety information and background information on glass cutting, tacking and more. But if you are struggling—or if you'd like more information—we strongly encourage you to seek out additional resources—especially the book this project originally appears in, Solder Technique Studio.

The inspiration for this project came from a die-cut paper bird I saw at the Craft and Hobby Association Tradeshow. There was a cluster of birds floating from one of the many amazing displays. My mind immediately envisioned a cluster of glass birds, with each section containing a different image or decorative paper. Again, this is a great alternative to your everyday tabletop flat picture frame. If you want to use it as a vehicle to display photos, skip the jump ring, use lead-free solder and use Jax Pewter Black Patina. Don't limit your creativity by thinking you have to make it the same size as the template. You can always increase the size of the pattern.

~ Josie

BASIC SOLDERING TIPS

+ *When soldering and cutting glass, always put safety first.*
+ *Always place your iron in a stand. Never set it down. Keep in mind that the stand gets hot, so always handle it by the base.*
+ *Only hold the iron by the handle; never grab it by the heating element.*
+ *Make sure your work table is well organized. Keep your table free of excess materials that you are not using.*
+ *OCD is your friend. Never leave a hot iron unattended.*
+ *Don't solder under a ceiling fan or air vent. Use a floor fan or open a window for ventilation.*
+ *Make sure your legs are under the table when soldering. Trust me— hot molten solder and skin don't mix.*
+ *Wear gloves and safety glasses when cutting glass.*
+ *Wear safety glasses and a mask when grinding glass.*
+ *When cutting glass, keep your cutting surface and floor free of glass shards, splinters or chips.*
+ *Wear rubber gloves when applying patina.*
+ *Don't eat while soldering.*
+ *No open drink containers.*
+ *Always wash your hands after soldering.*
+ *If you are pregnant, don't solder. You've waited this long, you can wait another nine months. Just look at the pretty pictures and dream.*
+ *Your piece gets hot. Wear gloves or use self-clamping tweezers to move or hold your piece in place.*
+ *You can't solder without flux. If your soldering isn't melting together or moving, apply flux or check your temperature control.*
+ *Do not drag your soldering iron when building a bead. A bead is a little BB-size blob of hot molten solder that looks like mercury from an old-school thermometer. Heat the solder all the way through using a tapping motion.*

+ *Don't use your iron like a paintbrush. The only thing this accomplishes is hair pulling and uneven bumpy solder with sharp points and dimples.*
+ *You have to melt your solder all the way through.*
+ *If the solder runs off your tip, your tip needs to be tinned or your temperature control is set too high.*
+ *If your solder sets with a dull, rough finish or will not flow, turn your iron up.*
+ *Clean your tip throughout. A shiny tip is a happy tip.*
+ *If you can't pick up a bead of solder, tin your tip.*
+ *You are not frosting cupcakes. Use flux sparingly.*
+ *Never spray glass cleaner directly on your piece. Spray your towel.*
+ *If your hands are shaky, add your jump rings another day. Go have a drink and put your feet up instead.*
+ *If you don't have a nice rounded edge, flux and add more solder. Melt the solder all the way through.*
+ *Don't overwork your solder or your piece. If your piece gets too hot, the glass can crack, the solder will have a rough, burnt appearance and copper-tape adhesive may ooze out from under the copper tape.*
+ *Make sure you apply your foil evenly and burnish well.*
+ *Practice, practice, practice your techniques for the sake of practicing.*
+ *Leave perfectionism at the door. Fixing one area almost always messes up another area.*
+ *If you want perfection, buy machine-made.*

materials needed

Shape template (below)

Round-tip Sharpie

Glass

Safety glasses and gloves

Toyo pencil-grip glass cutter and cutting oil

Cutting grid or piece of foamcore larger than the glass

Running pliers

Grozing pliers

200-grit diamond sanding sponge

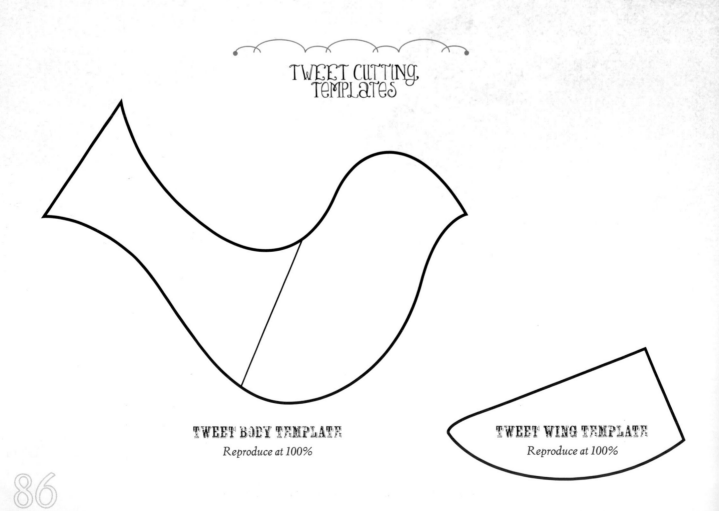

SAFETY FIRST

Make sure you wear safety glasses and gloves.

TWEET CUTTING TEMPLATES

TWEET BODY TEMPLATE
Reproduce at 100%

TWEET WING TEMPLATE
Reproduce at 100%

1 TRACE THE SHAPE OF THE PATTERN ONTO THE GLASS

Your glass should always be bigger than the shape. Here you will cut from the edge with the curve falling in the middle of the cut. (Because this is a free-standing dimensional piece that doesn't need to fit a predetermined size, I score along the outside of the marker line.)

2 BEGIN CUTTING THE GLASS

When cutting out shapes you will need good control. Use both hands to guide the glass cutter. Place one hand toward the middle of the cutter and the other directly below that with your fingers gripping the area just above the cutting wheel. Your hands should be stacked.

3 CUT THE INNER CURVES

Your hands should be stacked at this point. You will want to start by cutting the inner curves first and then any straight cuts. Be patient because it takes a series of cuts to release a shape from the center of a piece of glass.

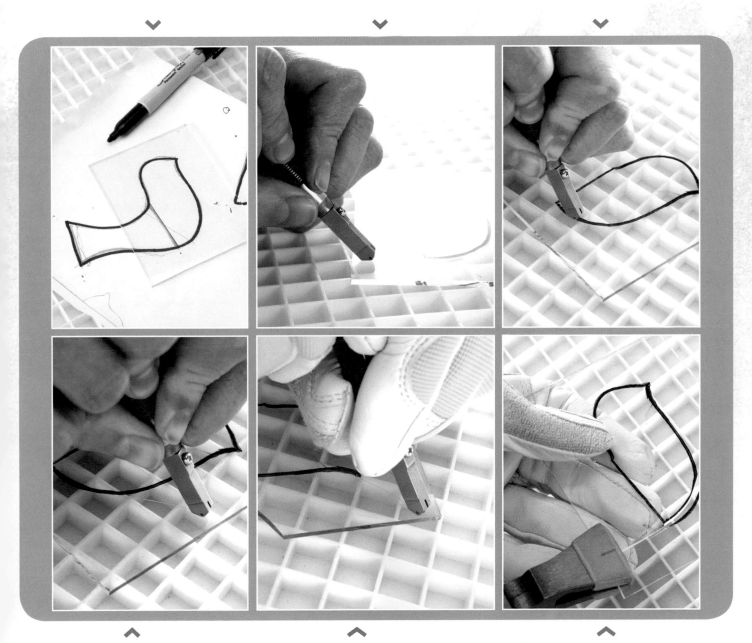

4 CONTINUE CUTTING THE CURVES

Start with the deepest curve. Place the cutter on the edge of the glass and start cutting until you meet the line.

5 FINISH CUTTING

Follow the curve until you feel you can't follow it anymore, then go off the edge of the glass.

6 APPLY PRESSURE TO THE GLASS

Don't forget about gloves and glasses—put them on now if you haven't yet. Use the running pliers and apply pressure on the line. Remove that piece of glass.

visit createmixedmedia.com/crafty-birds *for extras*

7 TRACE THE CURVES AGAIN
Place the cutter where you left off on the curve and follow that curve to the edge of the glass.

8 SEPARATE THE GLASS PIECES
Holding the glass firmly in one hand, use the grozing pliers and pull the cut piece away from the shape. Notice the open curve of the pliers resembles a smile.

9 REPEAT STEPS 5–8
Repeat steps 5–8 until all the curves are cut.

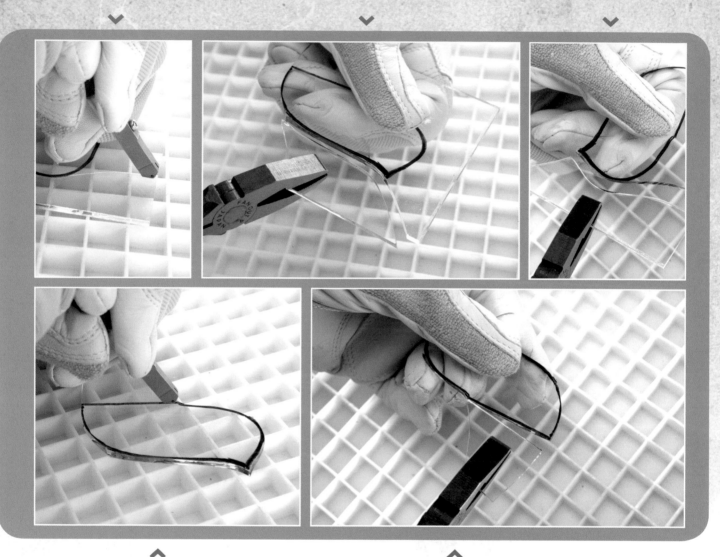

10 CUT THE STRAIGHT LINE
Cut along the straight line of the bird's back.

11 SEPARATE THE GLASS PIECES AND SAND
Use the grozing pliers and pull the cut piece away from the shape. File the edges and round off the pointed tips with a 200-grit diamond sanding sponge.

PART TWO: ASSEMBLING YOUR BIRD

materials needed

Solder, 60/40

Flux

Copper foil tape, cut to size

Glass, cut to pattern size

Patterned scrapbook paper, images or ephemera

Weights or boxes

Jump ring

Leather and rubber gloves

Novacan Black Patina

Cotton swabs

1 CUT THE DECORATIVE PAPER PIECES

Now that your glass pieces are cut, you will need eight pieces of decorative paper cut to size. Sandwich the papers between the pieces of glass and wrap the pieces with copper foil (see *Foil Wrapping* sidebar).

2 PIECE TOGETHER THE BODY OF THE BIRD

Tin all the pieces: Apply a layer of solder to build a round, beaded edge. You will tin the front, turn the piece over and then tin the back. Don't worry about any drips that occur during the tinning process; you will use those to build your beaded edge.

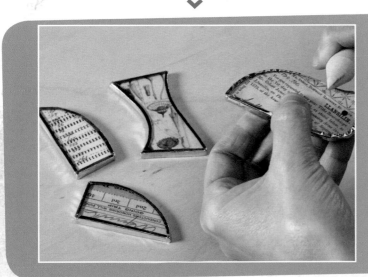
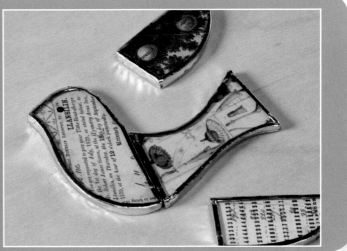

FOIL WRAPPING

1. Determine the width of the copper foil tape by clamping the paper and two panes of glass. Choose a width of cooper foil tape that will overlap the front and back a couple millimeters. Measure around the perimeter of the glass with the copper foil tape. Leave enough to overlap approximately ¼" (6mm) at the end.

2. Keeping the piece squared up, move the clamp so it faces away from you. Start the copper foil tape along the bottom center of each piece.

3. Once you have the tape started on the bottom center of the piece and the glass is aligned in the middle of the tape, place your thumb on top of the piece and your fingers on the bottom, preparing to rotate the piece clockwise as you affix the tape around the edges of the glass. Do not hold the clamp. Always have the paper backing and adhesive of the copper foil tape facing you, and always position your hands with a thumb on the top and fingers on the bottom.

4. Peel away more backing. Gently pull the copper foil tape taut and place the corner of the piece in the middle of the copper tape. Peel away more of the backing. Reposition your hands (thumb on top, fingers on the bottom) and move the clamp so it is facing away from you and rotate the corners into the middle of the copper tape. Again, gently pull the tape taut and place the next corner in the middle of the copper tape. Repeat until you have about two-thirds of the piece wrapped. Always reposition your hands with your thumb on top, fingers on the bottom and the clamp facing away from you. After two-thirds of the piece have been wrapped, you can take the clamp off.

5. Once you get to the end, even out the edges and overlap about ¼"(6mm) and trim off the excess.

6. With both fingers, push the sides of the copper foil tape down and tuck under at the corner, then overlap what you just tucked under. Continue to work your way around the piece tucking and pinching.

7. Burnish with a bone folder until you get a smooth seal. Push the corners down; don't worry if they look smooshed, they will be covered with solder. Don't forget to burnish the sides and where the copper foil tape overlaps. You are building the foundation of your piece, and it is important to get a good even wrap and a smooth tight seal on your burnishing.

8. Trim excess copper foil tape.

3 ADD FLUX AND TACK
Add a spot of flux at the seam and tack solder (see *Applying Flux and Tacking Solder/Tinning* sidebar).

4 APPLY FLUX TO THE WING
Wearing a leather glove on the hand that will hold the wing, place the wing on the seam in the middle of the bird and hold at an angle. Apply flux.

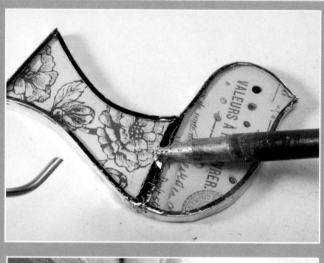

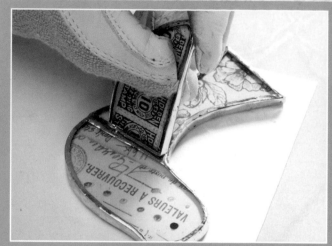

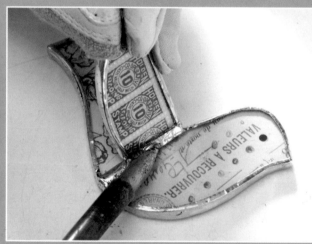

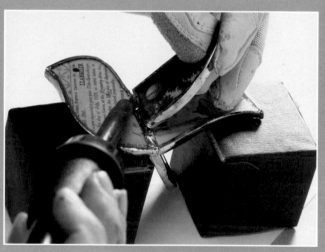

5 ADD BEADS OF SOLDER
Add beads of solder to build up the bead.

6 ATTACH THE SECOND WING
Using two weights or boxes, balance the bird as shown. Attach the other wing. Once the other wing is attached, build your bead around the outer edges of the bird and fill in any gaps with solder.

APPLYING FLUX AND TACKING SOLDER/TINNING

1. Using a cotton swab, apply a thin layer of gel flux to the front, back and sides of each piece.
2. Use the length of the solder coming off the roll to hold the piece in place while soldering and start by tinning the front and back of the piece. Once your iron is heated to the right temperature, pick up a bead of solder with your iron tip. Position the bead on the top edge of the copper foil tape. Once it starts to melt onto the copper foil tape, pull the solder along the edge of the tape in one fell swoop. Do not use your iron like a paintbrush. If you don't have enough solder to finish one edge, get another bead. Start where you left off and melt the solder together, then pull the bead along the edge of the tape.
3. Fight the urge to fix any drips. Use cross-locking, self-clamping tweezers or a gloved hand to turn the piece over and tin. Work in a systematic way and continue tinning the other side.

7 ATTACH A JUMP RING
Use weights or boxes to brace the bird in a standing position and attach the jump ring.

8 CLEAN AND PATINA
See *Adding Patina* sidebar.

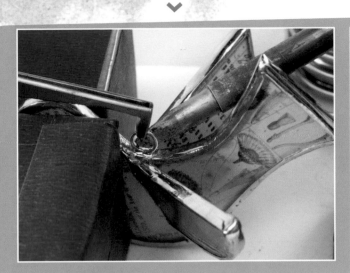

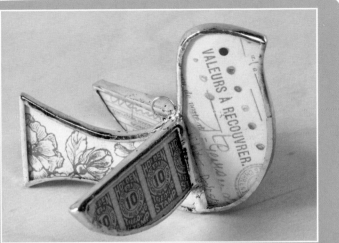

ADDING PATINA

Patina liquid will give an antiqued look to your finished piece. Pour a small amount of patina (Josie recommends Novacan Patina) into the cap of the patina. With a cotton swab, apply the patina to all the soldered areas. (Never insert a dirty cotton swab inside the patina bottle as you risk contaminating the patina.) Discard any patina remaining in the cap. The patina will dry quickly and you can then apply wax or polish over the patina for added luster. Keep in mind the patina might change color with the addition of wax or polish, and be careful not to overbuff.

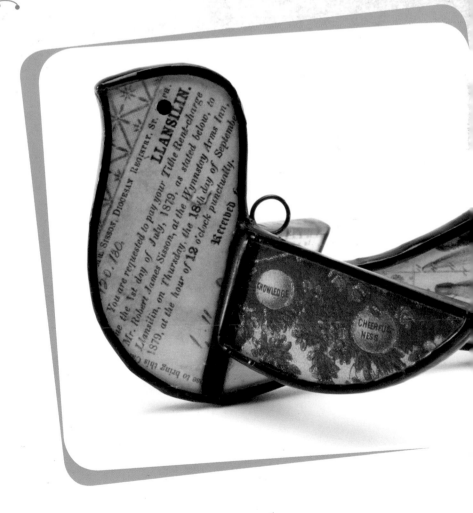

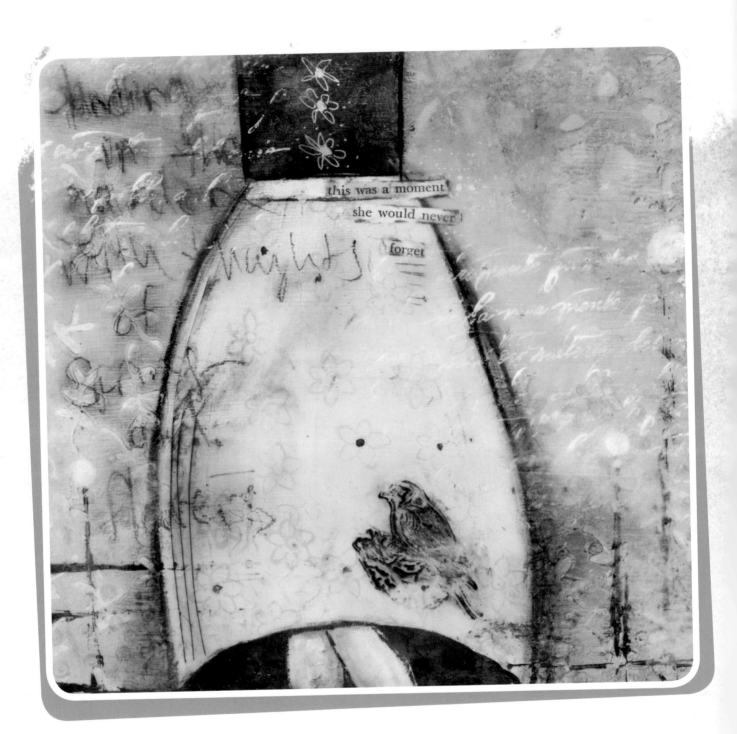

this was a moment

she would never

forget

LEARNING TO SOAR
From TAKING FLIGHT *by Kelly Rae Roberts*

For this project my goal is to incorporate multiple mixed-media techniques into one finished work. But it is so hard to choose just a few! Ultimately, I decided to try enhancing a painting with journaling and then, once the painting was complete, transforming it into an encaustic work.

The term "*encaustic*" refers to using melted beeswax in a work of art. Prior to this project, I had never made an encaustic painting but had always wanted to learn—and it was great fun to experiment with! Along the way, you'll also learn some of my favorite ways to create a textured, multilayered background with rubber stamps and to add lines of interest without buying any fancy new tools.

~ Kelly

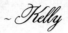

materials needed

ENCAUSTIC PAINTING

- Beeswax
- Metal stamp
- Burnt umber oil paint
- 2" (5cm) bristle brush
- Small potpourri simmer pot, slow cooker or pan and stove
- Craft knife
- Rubber gloves
- Heat gun
- Paper towel

ADDING TEXTURED LINES

- Acrylic paint
- Old, expired credit card

ENHANCING YOUR PIECE WITH JOURNALING

- Old book
- Soft graphite pencil
- Charcoal pencil (optional)
- Gel medium
- Craft knife

CREATING A TEXTURED STAMPED BACKGROUND

- Block of wood, 7" × 7" (18cm × 18cm)
- Rubber stamps, 3
- Heavy-bodied acrylic paints in assorted colors
- Foam brush
- Gesso
- Paper towels

NOTE: CREATING A TEXTURED STAMPED BACKGROUND

We'll play around with stamps for this part of the project, giving our background a rich, textured appearance. Be careful, though; using stamps in your paintings can be addictive! It makes it nearly impossible to stop into a craft store without buying a new one every time!

visit createmixedmedia.com/crafty-birds *for extras*

1 GESSO THE WOOD SURFACE

Use a foam brush to gesso the surface of the wood. Allow it to dry all the way. If you wish, you can use a heat gun to speed up the process.

2 PAINT THE BACKGROUND

Select or mix a shade of heavy-bodied acrylic paint you'd like to use as the primary background color. Use your foam brush to apply a coat of paint to the gessoed surface.

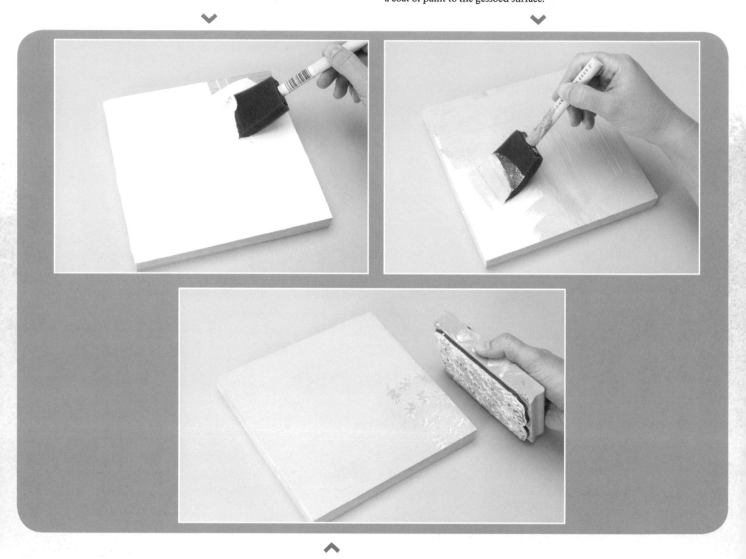

3 STAMP THE DESIGN INTO WET PAINT

While the background paint is still wet, press a stamp firmly into the paint to make an impression. Repeat until you've created a texture you like, and then allow the surface to dry. (Again, you can speed this up with a heat gun if you wish.)

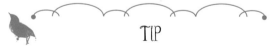

TIP

I like to stamp into heavy-bodied acrylics (as opposed to fluid acrylics) because when you stamp into them, the rubber picks up more paint color, allowing for a more dramatic effect.

4 STAMP ANOTHER DESIGN AND PAINT COLOR
Mix or choose a coordinating color of heavy-bodied acrylic paint. Here I simply added a blue shade to my green background paint to create a turquoise color in the same palette. Brush the paint directly onto a different rubber stamp, and press it onto your surface to transfer the pattern.

5 BLOT THE EDGES
Use a paper towel to blot the edges and soften the stamp impression. Blot until you've refined the second layer of the background to the level of texture and color you like.

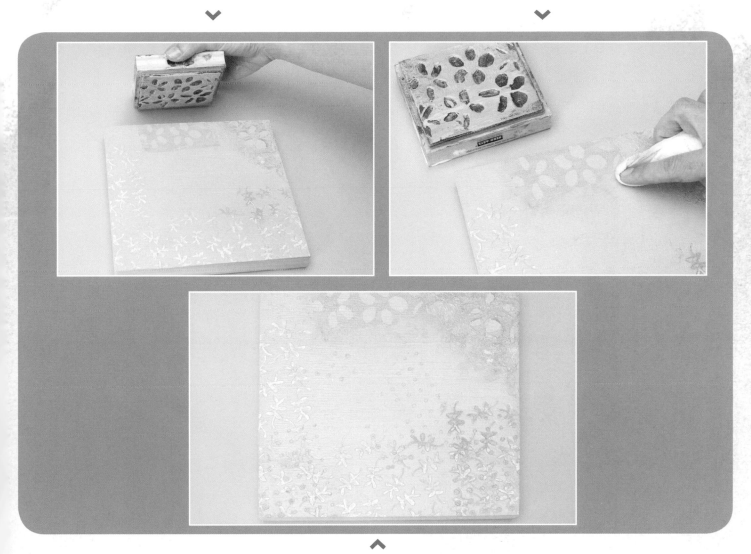

6 ADD A THIRD LAYER OF TEXTURED STAMPING
Select a third stamp, brush some more of the second color of paint onto it and stamp it randomly over the surface to add yet another dimension to the texture. Allow it to dry. Now your beautifully textured, stamped background is ready, and you can go on to paint the subject of your choice.

TIP

It's very important to clean acrylic paint off of your stamps immediately, or you will ruin your stamp when the paint dries on the rubber.

7 ADD PAINT WITH A CREDIT CARD

After you've painted your subject matter, load the edge of a credit card with paint and use it to add lines of texture to the surface of your background. You can apply different amounts of paint and pressure to make pencil-thin lines or heavy lines, depending on your preference.

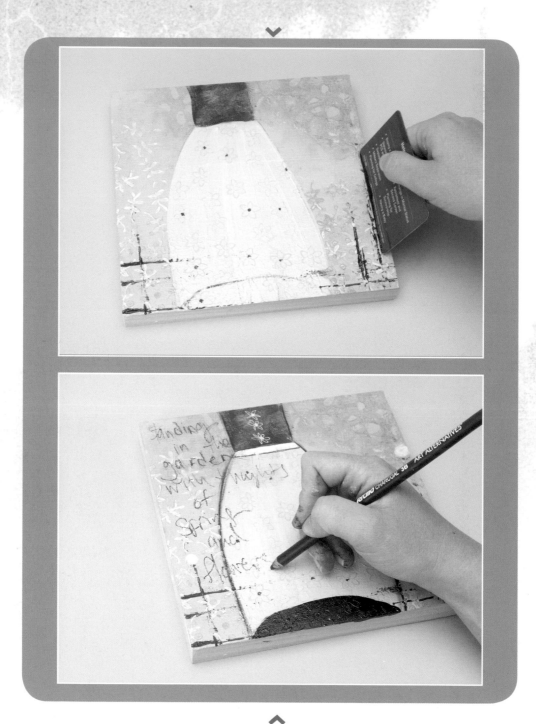

8 WRITE WITH A PENCIL OVER THE DRY BACKGROUND

Journal on the background with a soft graphite pencil. It can be as neat or as messy as you like, as readable or illegible.

9 BLEND THE GRAPHITE AND ADD COLLAGE WORDS

Use your finger to blend the graphite and soften it. Again, you can leave it as clear as you want, or make it almost illegible. Use a craft knife to cut any words that strike you as significant from an old book. This is another way to enhance the meaning of your work. Here I selected *This was a moment she would never forget*. Use gel medium to adhere them to your subject. If you'd like, you can use a charcoal pencil to trace around the edges and enhance your cut-out words.

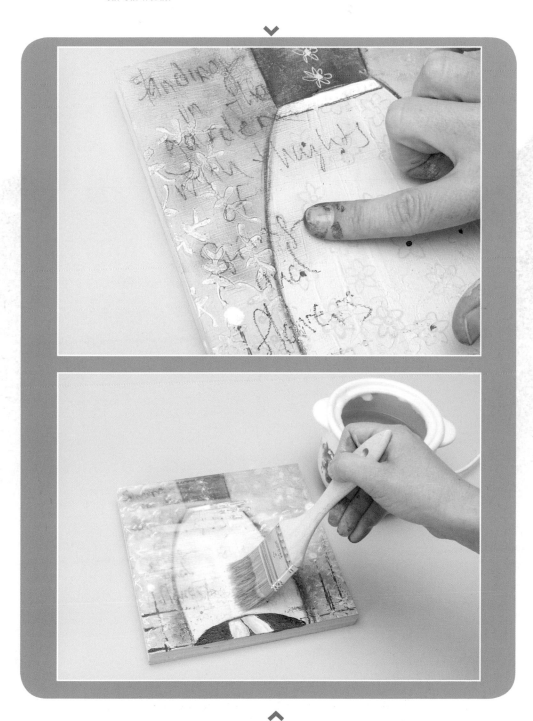

10 BRUSH BEESWAX ONTO THE SURFACE

Melt beeswax in a small potpourri simmer pot, in a slow cooker or on the stove. (The recommended temperature is 225° F [107° C].) Use a 2" (5cm) bristle brush to apply a layer of wax over the surface of the piece.

11 SMOOTH THE BRUSH MARKS WITH HEAT
Use a heat gun to melt the brush marks into a smooth, matte surface.

12 STAMP IMPRESSIONS INTO THE COOLING WAX
Let the wax set until it's no longer hot but not yet cold. Use a metal stamp or object to make impressions in the drying wax surface.

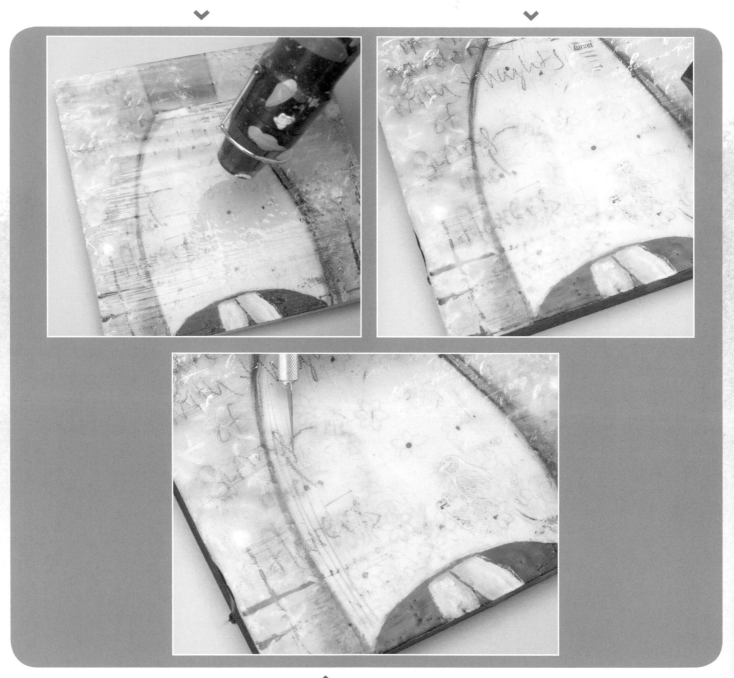

13 CUT DETAIL LINES INTO THE WAX
Use a craft knife to carve small lines into the wax in areas that you think could use more definition or texture.

14 APPLY PAINT TO THE STAMPED AND CARVED AREAS

Take a bit of burnt umber oil paint (a great color for distressing) and use your fingers to rub it thoroughly into the impressions you made with the stamp and the knife.

15 RUB PAINT FROM THE SURFACE

Using a paper towel, rub the excess oil paint off of the surface, leaving only the distressed, inked impression behind.

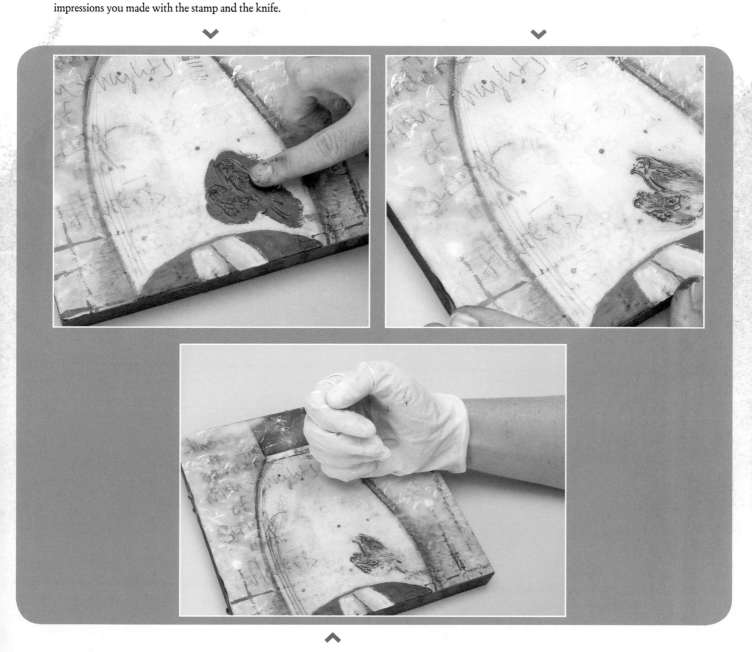

16 BUFF THE WAX

Put an ordinary rubber glove on your hand and give it some time to warm a bit to the heat of your hand. Use the side of your warm, gloved hand to buff the surface of the wax until the finish has a sheen to it.

TIP

Buff the surface of your encaustic work every few months to restore the satiny surface. With regular maintenance, eventually the wax will stop "blooming" and stay satiny in appearance.

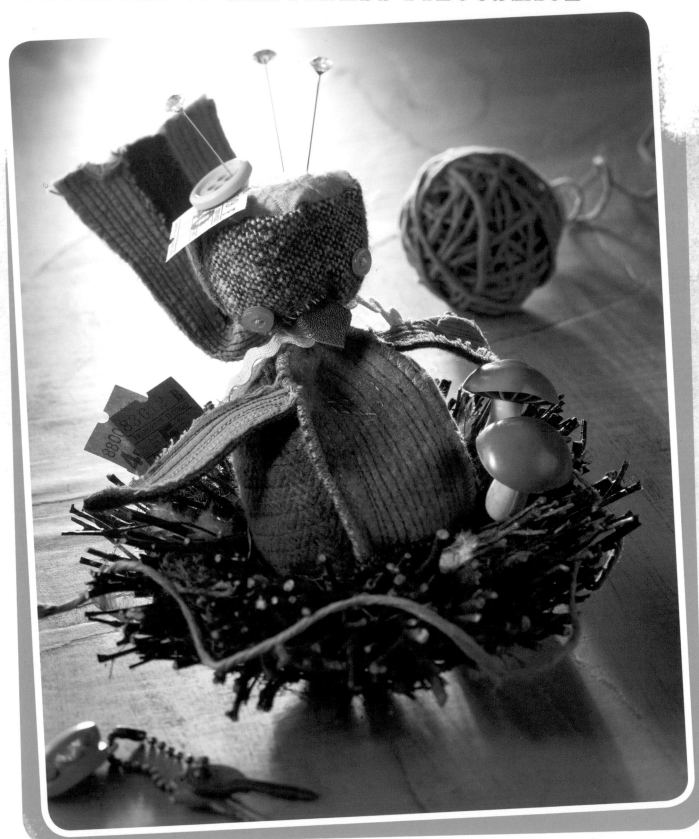

BLUEBIRD OF HAPPINESS PINCUSHION
From Mixed and Stitched *by Jen Osborn*

Over the last couple of years, I've noticed that birds seems to be making their way into my home and art. I've loved birds my whole life, but in the past they never really did much for me artwise. That all changed when I met my friend Melody—she taught me the magic of birds in art, and I've loved incorporating them in my pieces ever since. Hands down, this is my favorite project in the book because I now have my own Bluebird of Happiness that's functional and fun. I can guarantee that you will love making this pincushion as much as you will enjoy displaying it in your home. Don't be put off by the fact that it's blue—you could easily make any kind of bird by tweaking the colors to match the ones in your mind's eye.

~ *Jen*

materials needed

Brown tweed scraps (bottom and head), 2

Turquoise fabric scrap (tail base)

Coordinating blue fabric strips (tail strips), $3/4$" × 9" (19mm x 23cm), 3

Blue fabric scrap (breast piece), 2" × 4" (5cm 10cm)

Brown scraps (body piece), 4" × 5 $1/2$" (10cm x 14cm), 2

Aqua fabric scraps (top head circle)

Blue fabric scraps (wings), 4

Brown scraps (head), 2 $1/4$" × 3 $1/4$" (6cm x 8cm), 2

Small scrap of brown leather or vinyl (beak)

Narrow blue rickrack, 9" (23cm)

Bluebird templates

Buttons (small, for eyes), 2

Coarse white or cream thread (i.e., nettle yarn)

Red fabric pen

Sand, 1 cup (237 ml)

Scissors

Sewing machine

Sewing needle

Stuffing, 1 cup (237 ml)

Thread

Wooden craft circle, 2 $1/2$" (6 cm)

Optional: white gel pen

1 CUT CIRCLES AND FELT THEM TOGETHER

Place the wood craft circle on a scrap of brown tweed and trace a circle on to your tweed ¼" (6mm) wider than the wooden circle. Using the bluebird templates (located at the end of the project instructions), cut a tail base out of a turquoise fabric scrap. Working with the ¾" × 9" (19mm × 23cm) coordinating blue fabric strips, lay one strip on top of the tail base fabric, and faux felt them together (see *Faux Felting Technique* sidebar). Repeat this process to attach the two side strips to the tail base, slightly overlapping the side strips over the middle strip so there are no gaps.

2 TRIM FABRIC EDGES

Trim any stray edges and reinforce the curl by pulling your thumb down the length of the tail, like you are curling a birthday ribbon. This will also help rough up your fabric scraps, giving the project more of a handmade look.

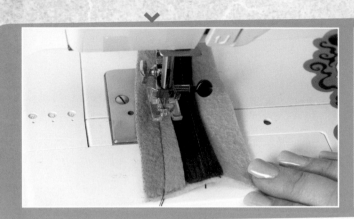 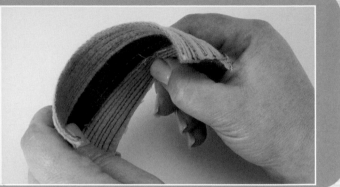

TIP

Experiment with the tail shape by not sewing all the way to the end of one strip of the tail. As you faux felt that strip down, you will see it start to curl away from the backing. If you'd like to use narrower strips, feel free—you'll just need more!

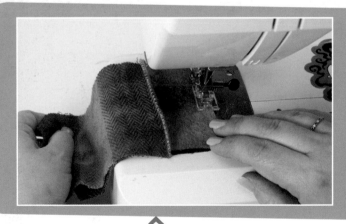 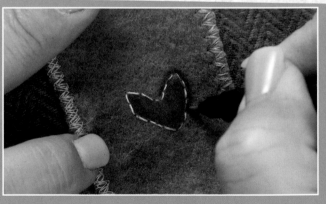

3 SEW THE BODY PIECES TOGETHER

Put one brown body piece wrong sides together with the blue breast piece, aligning the 4" (10cm) sides. Use a variegated or contrasting thread to satin stitch up and down one long side to connect them; sew back and forth until you're sure no sand will be able to escape. This is meant to look rustic, so don't worry about perfection! You want these stitches to be seen. Repeat with the other brown body piece by sewing it to the other side of the breast piece, wrong sides together.

4 HANDSTITCH A HEART ONTO THE BODY

Using a coarse thread (I like nettle yarn), stitch a small heart shape onto the center breast piece, approximately 1½" (4cm) up from the bottom and just right of center. Snip your threads and color the heart in with a red fabric pen. Draw a red outline around the outside of your stitches, too. If you color over your stitches by accident, simply go over them with a white gel pen.

TIP

Any time you stop to adjust your fabric, make sure your needle is down. The needle will help hold your material in place and keep it from shifting while you adjust.

FAUX FELTING TECHNIQUE

This is one of my favorite techniques, and it's the one I use most often to make something really special for my friends. I call this technique Faux Felting because, just like needle felting, it mashes two or more fabrics together to create one thick, amazing, malleable piece of fabric. It is an extremely simple process, although it is a bit tedious and time consuming—just listen to music, go into reflection mode and sew away!

1 CHOOSE MATERIAL FOR FELTING

Choose two materials, each larger than the shape you are going to cut out. I've found that this technique works best with at least one thick fabric like wool, felt or even an old sweater sleeve. When you use a thicker fabric, you have more to mash down into your ultra-felted piece. I'm using a bright orange piece of dyed bamboo quilt batting and a piece of wool suiting. These nice, fluffy fabrics will result in a wonderfully dense felted piece.

2 SEW PIECES WRONG SIDES TOGETHER

Lay the two material pieces on top of each other, wrong sides together, and slip them under the presser foot. Using a short stitch length and coordinating thread, begin sewing in the center and stitch out toward one edge. Then, snip your threads, go back to the middle and sew out to the opposite edge. Sew straight rows about 1/8" (3mm) apart, using the presser foot as a spacing gauge. Keep stitching parallel rows until you have covered the entire surface, really mashing and molding the fabrics together.

3 SEW AGAIN, IF NECESSARY

Once you've removed the fabric from your machine, if you feel like your rows are too far apart or that your fabrics aren't felted together enough, simply stick it back in your sewing machine and sew more rows until your felted piece looks and feels right. I don't know the physics behind it, but sewing fabrics together like this changes their composition and makes a pliable piece. You can use your thumbnail to give it a curl, like a ribbon.

4 CUT OUT SHAPES

One of the neat side effects of this process is that as you mash your layers together with your sewing machine, you actually stretch them out of shape, a bit like using a rolling pin on pie crust. This means that you can cut out any shape and your fabrics won't unravel or fray. Use a sharp pair of fabric scissors to cut out your shape.

TIP

This technique stuffs a lot of lint down into your bobbin case. Clean out the debris every time you sew up a batch of faux felt!

5 ADD DECORATIVE STITCHING

Using the faux felting technique, sew vertical columns up and down the breast piece and horizontal rows on the side pieces with the same thread you used to sew on the tail. Use a short stitch length and sew your columns/rows close together, leaving about $^1/_8$" (3mm) between rows. This stitching is purely decorative!

6 SEW THE BREAST PLATE TO THE MAIN BODY

Lay the tweed bottom circle in the center of your body piece, right sides together, aligning the edge of the circle with the bottom edge of the body. With a narrow zigzag stitch, begin sewing the bottom edge of the body piece to the edge of the circle. Sew slowly from the center of the breast piece in one direction, easing the fabric around the circle as you sew. Stop once you have sewn halfway around the circle, go back to the center of the breast plate and continue sewing in the other direction.

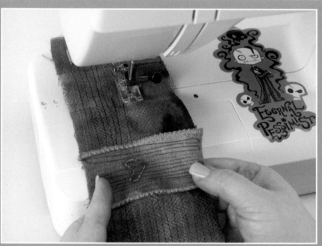
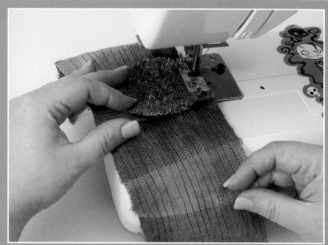

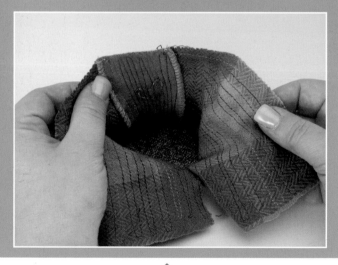
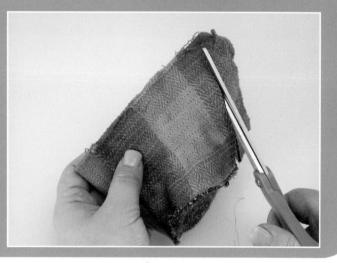

7 SEW UNTIL THE BODY FABRIC IS SEWN AROUND THE ENTIRE CIRCLE

The body will start to curve into a rounder shape as you go. Sew until the body fabric is sewn all the way around the circle. Remove the body from the machine and make sure there are no gaps in the seams for sand to escape. The body will be inside out at this point.

8 CUT FLAPS TO SHAPE THE TAIL

Fold the sewn body in half from the center of the breast fabric to the back point. Holding the breast-piece side in your left hand, squeeze the body flat and cut the flaps of fabric on your right into an angle sloping up and out from your base circle. This will give the bird body the proper shape to add a tail onto later.

![bird silhouette decoration]

TIP

If you get to step 9 and your circle won't fit inside the body section, don't panic! Just take coarse sandpaper and sand around the circumference of the disc to make it fit.

9 STITCH ALONG THE SEAMS TO SECURE

Satin stitch along the angled line you just cut—the stitching won't show so any thread will do. Stitch back and forth several times so the seam is extremely secure. Carefully turn the body right-side-out. Poke out the corners with your fingers and make sure there are no gaps. Push the wooden craft circle into the bottom of the body. It should fit snugly all the way down in the base. Set the body aside.

10 CUT AND SEW THE WINGS

Use the wing template to cut two wings from dark blue felt, and cut two slightly larger rectangles from turquoise fabric. Place one blue wing on top of the turquoise fabric, wrong sides together. Faux felt the pieces together using blue thread and a short stitch length, slightly following the curve of the wing as you sew. Repeat for the other wing, but flip the blue felt the opposite way so you have one right and one left wing. Run your thumb over the wings to accentuate the curl and trim them down to the size of the smaller wing, removing the excess turquoise fabric.

Next, take the right wing, turquoise-side-out, and butt the narrow end up against the right body side seam at a height that looks right to you. Whipstitch the short end of the wing in place until secure, hiding the stitches and knots on the inside of the body. Repeat to sew on the second wing. Phew! Wipe the sweat off your brow, and go refill your coffee cup.

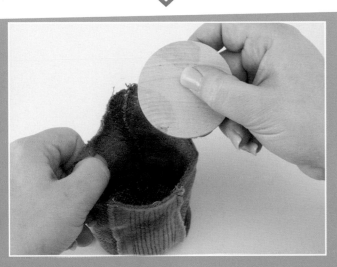

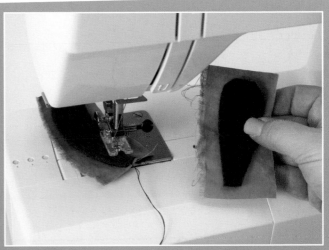

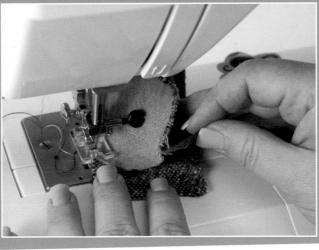

11 SEW THE HEAD

Place the two brown head rectangles right sides together. Using a tight zigzag stitch, sew together one short side, going back and forth several times until securely closed. This time, the zigzag stitches will be on the inside and your tidy seams on the outside.

Cut out a head circle from the aqua scrap using the head circle template. Place the right side of the head together with the turquoise head circle, and sew them together as you did with the body: Start at the center of the brown fabric rectangle, and sew out in each direction until you have about 1/2" (13mm) of unsewn fabric at each end.

12 FINISH SEWING THE HEAD

Zigzag the back seam of the head closed, starting at the open end and sewing toward the blue circle. You are still sewing with the wrong sides of the head out and right sides in. When you reach the gap you left along the blue circle, finish sewing the head fabric to the circle, closing it all up.

13 SHAPE THE HEAD AND ADD THE EYES

Turn the head right-side-out, poking the seam open with your fingers as you go. If you notice any gaps, simply turn it back inside out and restitch until closed. Use a needle and a long piece of coarse white/cream thread to sew on two small blue buttons as the bird's eyes. The eyes should be sewn on about 1/2" (13mm) down from the top of the head, and 1/2" (13mm) in from each side seam.

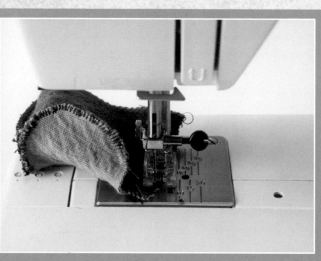
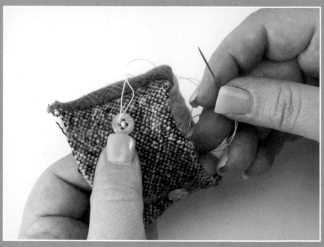
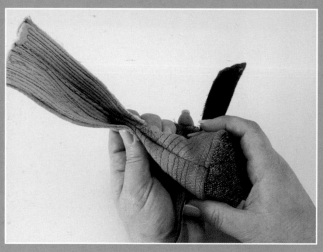
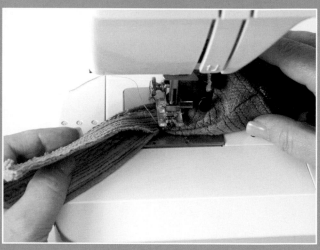

14 HOLD THE TAIL TO THE BODY

Now it's back to the body for a bit. Fold the body in half, right-side-out, and fold the tail in half lengthwise with the striped side up. Sandwich the back body fold into the fold of the tail. Slide the folded edges under your presser foot and lower the foot to hold everything in place. I'd tell you to pin it in place, but it's really too thick at this point and too unwieldy to get under your presser foot with the pin, so just use your pinchers and keep at it.

15 SEW THE TAIL AND BODY TOGETHER

Using a matching thread, sew the tail to the body with a tight zigzag. Secure the two parts together by going back and forth multiple times. Start in the middle, and work your way out to the edges, and back in. This is one of the most difficult steps of this whole project, so try not to get discouraged, and definitely don't worry about perfection here! You want to sew just past the edges of the tail onto the body in order to close up the fold at the back of the tail. Once you've got it sewn on really well, use your fingers to open the fold of the tail and bend the end up.

And remember: It's the back end of the bird—just let it go!

16 STUFF THE HEAD AND BODY

Stuff the head with stuffing and fill the body with about 1 cup (237ml) of sand. Fill both the head and body as full as you can while still being able to pinch the open ends closed. Filling the body with sand does two wonderful things: It makes the base heavy and sturdy so your bird won't keep falling over, and it will sharpen your needles and pins as you stick them into the pincushion. You need to use stuffing in the head so it's lighter and won't flop over at the neck. Collect sand on vacations so you can stuff your pincushions with wonderful memories.

TIP

To sew a running stitch, simply stitch in a line, going in and out of your fabric every 1/8" (3mm) or so. Your fabric will automatically gather a little as you sew and will do so even more when you pull your thread taut.

17 SEW THE HEAD CLOSED

Using a really sturdy thread, sew the neck of the head closed, hiding your knots on the inside. Use a wide running stitch starting about 1/4" (6mm) down from the opening. Go in and out of the open neck all the way around, pulling the thread snug as you go. When you get back to where you started, pull the thread taut to gather the opening as you close up the hole. Then run stitches back and forth through the entire pucker in an asterisk pattern to really close the neck up tight. When you finish stitching the head closed, don't snip your thread ends short—leave them to use later to sew the head onto the body.

Repeat with the open neck hole of the body, starting the running stitch at the tail seam. When you get back to the tail, put your needle in on one side and come out on the other. This will gather your body around the tail and make it sturdier. Tie a secure knot in the fold of the tail and stitch up through the pucker to hide your thread ends. This time snip the thread ends short. Use your fingers to shape the sand in the body as you sew it up, pushing it around until it looks how you want it to.

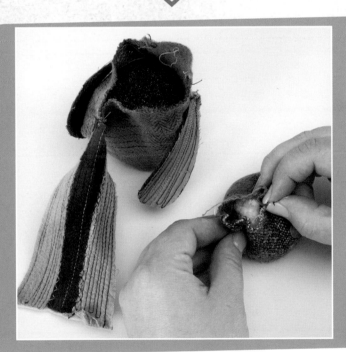

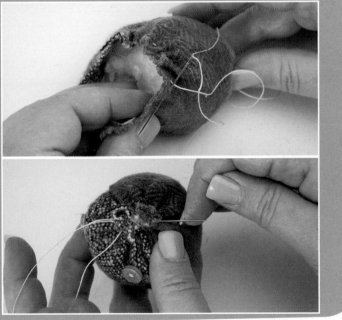

TIP

I like to sew on two slightly different size buttons for eyes to make my creatures a little quirky. I'm not talking about a huge difference here, just enough to add a little variety. I recommend using four-hole buttons so you can really attach them well. Your pincushion is going to get lots of wear and tear, and you'd hate for an eye to pop off along the way!

When sewing on the tail, there are a lot of layers to stitch through, so go back and forth multiple times. Try flipping the entire body over and stitch again from the other side. This helps ensure that the tail's sewn on everywhere, not just what you can see on one side.

18 MAKE AND SEW THE BEAK ONTO THE HEAD
Cut a small triangle from the leather scrap using the bluebird beak template. Rethread your needle with the thread hanging from the head piece. Stitch up through the inside of the head and out through the center where you want the beak to be. Starting in the center of the beak, whipstitch along the top edge to secure it in place, folding the leather triangle into a curved beak shape as you sew. Don't knot your thread when you are finished—stitch back into the head and down through the neck. Do not snip your threads short.

19 ATTACH THE HEAD TO THE BODY
Use the remaining thread to attach the head to the body. Hold the two puckers together and stitch back and forth through both parts until the head is securely attached and doesn't wobble around. Don't worry about stitching pretty, everything will get covered up in the next step. Once you have the head firmly attached to the body, snip your thread short.

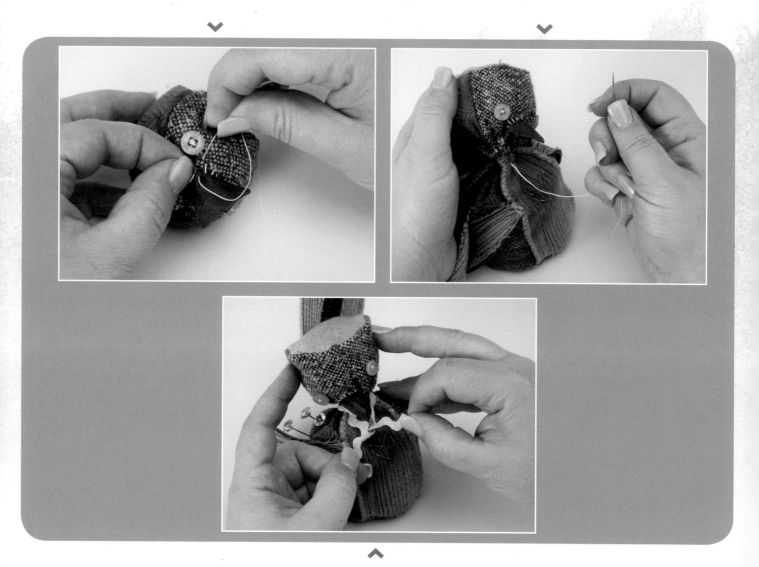

20 TIE RIBBON AROUND THE BIRD
Tie a small piece of rickrack (or ribbon) around the neck to hide where you connected the head to the body. You now have your own Bluebird of Happiness. Find a wonderful spot for it in your home or studio, stick in some fancy-schmancy pins and enjoy!

TIP

Rest the head on your thigh while you stitch on the beak. This frees your hands up and gives you more control.

BLUEBIRD OF HAPPINESS
TEMPLATES

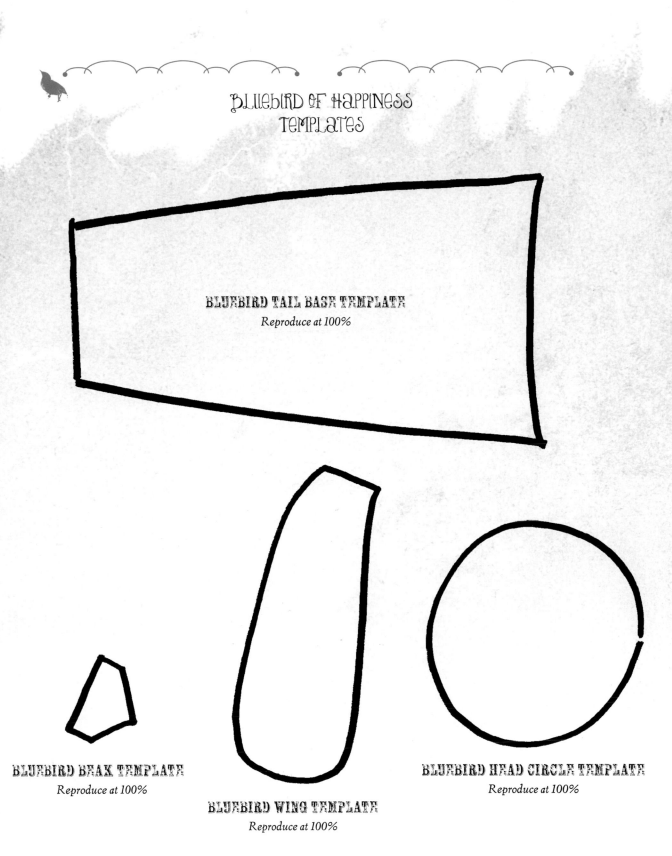

BLUEBIRD TAIL BASE TEMPLATE
Reproduce at 100%

BLUEBIRD BEAK TEMPLATE
Reproduce at 100%

BLUEBIRD WING TEMPLATE
Reproduce at 100%

BLUEBIRD HEAD CIRCLE TEMPLATE
Reproduce at 100%

TWO BIRDS ON A BRANCH

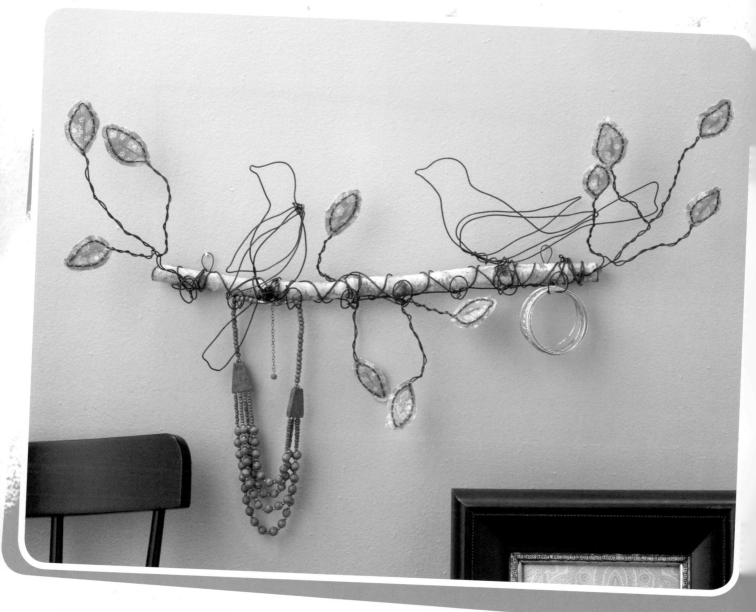

TWO BIRDS ON A BRANCH
From CREATIVE BLOOM *by Jennifer Swift*

Inspiration often comes to us when we least expect it. I was helping my mother sort through her old teaching supplies one day when I came across a 1950s primary schoolbook on birds. Within the pages were birds in nests, birds on branches, birds in flight—all charmingly illustrated. I wondered if I could use wire to capture the forms of these birds. It took many attempts, but in the end the cute little backward-glancing bird became one of my absolute favorites!

Another artist suggested I make some jewelry displays. I took up the challenge and came up with *Two Birds on a Branch.* This display can be used as intended for jewelry, or it could hang in your kitchen to hold pot holders and utensils. No matter where you put it, these sweet little birds will guard your treasures with hand-crafted style.

~ Jennifer

Birch branch, approximately 23" (58cm) long

Craft wire, 19-gauge

Dark annealed steel wire, 16-gauge

Embroidery floss

Fabric scraps

Needle-nose pliers

Scissors

Sewing needle

Straightedge

Wire cutters

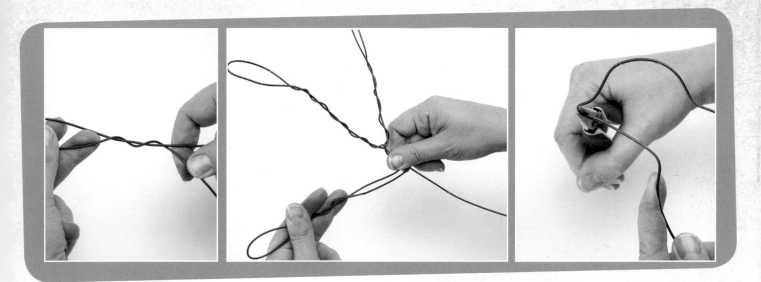

1 CREATE A LOOP

Working from the spool with 16-gauge wire, create a 2" (5cm) loop 10" (25cm) from the cut end. Twist the wires together until the twisted section is 4" (10cm) long. This creates a leaf and a branch segment. Use needle-nose pliers to shape points at the ends of the leaves if desired.

2 MAKE FOUR MORE LOOPS

Bend the wire from the spool away from the twist. Create a second 2" (5cm) loop 6" (15cm) away from where the twist ends. Wrap the wire back to the first twist. Continue to loop and twist the wire in this manner to create five leaves and branches. Cut the wire from the spool, leaving 6" (15cm) of excess to attach the piece to the birch branch.

3 SHAPE A BIRD

Working from the spool with 16-gauge wire, begin shaping a backward-glancing bird by creating a slight curvature for the bird's head 14" (36cm) from the cut end. Using needle-nose pliers, bend the wire to create the bird's beak and then form the bird's back. Shape the tail and the underside of the bird. Return the wire back to the neck of the bird, just below the first bend.

Note: To create the birds in steps 3–5, you can also use the templates as a guide (the templates are located at the end of the project instructions).

4 BEND THE WIRE TO SHAPE THE WINGS

With pliers, bend the wire sharply to the left to create a wing shape. Cut the wire, leaving 12" (30cm) of excess. Wrap this wire tightly around the wire at the neck and through the first wing to secure it loosely. Shape the second wing and return the wire to the neck. Wrap the wire tightly around and through the first wing and then cut the wire, leaving enough excess to attach the bird to the branch.

5 SCULPT A SECOND BIRD

Make a second bird as demonstrated in the *Sculpting Instructions* sidebar; however, after shaping the first wing, shape a second matching wing on the opposite side of the form. When cutting the wire, leave enough excess to attach the bird to the branch. Attach the birds to opposite sides of the branch with the excess wire.

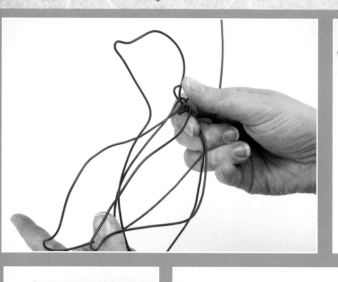
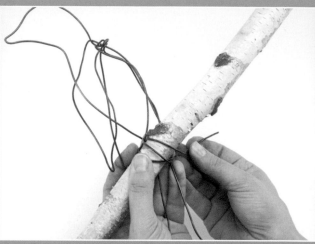
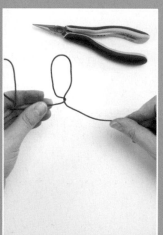
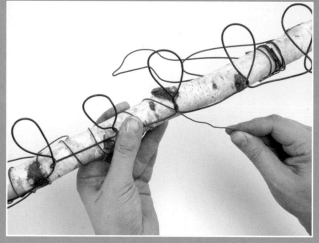
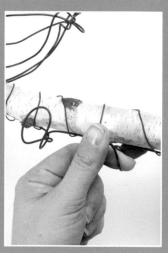

6 CREATE HOOKS

Make a 2" (5cm) loop 7" (18cm) from the cut end of the 16-gauge wire. Twist the loop twice, and then straighten the next 2" (5cm) of wire. Continue making these loops, spacing them 2" (5cm) apart, until you have enough loops to fill the length of the birch branch (about seven hooks). Use a straightedge to ensure the loops are evenly spaced.

7 ATTACH THE WIRE BRANCHES TO THE BIRCH BRANCH

Use pliers to wrap the wires securely. To attach the hooks to the branch, hold them against the branch so the hooks stick straight out from the bottom. Pull an arm's length of 19-gauge wire from the spool and, starting from the middle of the branch, wrap it around the branch and the hooks. Once you've reached the cut end, wrap the wire a few more times to secure and then cut off any excess. Return to the middle of the branch and wrap the wire from the spool to the other end. Secure the wire and cut. Bend in the cut ends.

8 BEND THE HOOKS AND ADD EMBELLISHMENTS

Using your finger or pliers, pinch the center of the hook loops and bend them up. Using a needle and embroidery floss, sew small fabric scraps to the leaves and trim, leaving ¼" (6mm) allowances. To hang this piece, make two wire loops and secure one at each end of the branch.

WIRE BIRD TEMPLATE

Reproduce at 200%

SCULPTING INSTRUCTIONS

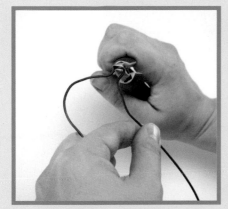

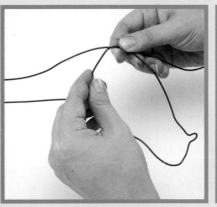

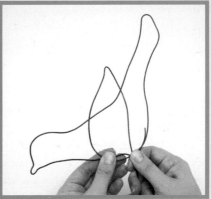

1 Working from the spool, use pliers to bend 16-gauge wire 5"–6" (13cm –15cm) from the cut end to form a beak. Shape the head and back of the bird with your hands and then make a U-shape for the tail. Bring the wire to the cut end again to form the rest of the bird's body.

2 At the bottom of the bird, bend the wire up and shape one wing.

3 After shaping the wing, return to the bottom of the bird and twist the ends together several times. Cut the wire, leaving 5"–6" (13cm–15cm) excess to attach the bird to the wood scrap. Twist the tail once. The finished bird should measure approximately 9" × 10 ¹/₂" (23cm × 27cm).

CAST OBJECT ASSEMBLAGE

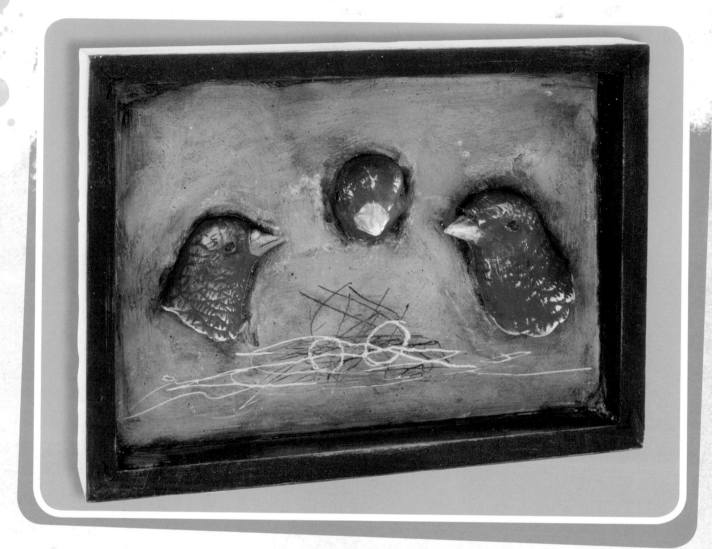

CAST OBJECT ASSEMBLAGE
From PLASTER STUDIO *by Stephanie Lee*

One of my favorite things to do with plaster of Paris is to reproduce objects that are one-of-a-kind or that I want to create duplicates of. Here I've taken a thrift shop bird figurine with simple detail and cast it from three different angles. The Sculpey clay is firm enough to hold the shape of the object, smooth enough to capture intricate detail and dry enough not to stick to the object itself. Also, because it is the oven-dry variety, it will stay flexible while the plaster is hardening in open air.

I've cast so many different things and am amazed at how perfect the tiniest, most intricate details are captured in the casting as long as the clay mold is prepared properly. The only downside to this technique is the desire to carry a wad of clay around with me all the time in case I come across anything I might want an impression of.

~ Stephanie

materials needed

Clay (Sculpey)

Found object to cast (I used a bird figurine)

Plaster of Paris

Craft knife

Cradled picture frame with rigid panel backboard

Masking tape

Two-part epoxy

Assorted paintbrushes

Acrylic paints, assorted colors (including burnt umber)

Damp rag

1 PRESS THE DESIRED OBJECT INTO THE CLAY

Soften a lump of clay and create a ball similar to the size of the object you are going to cast. Push the clay onto the object. With the object still in the clay, press the bottom of the clay onto a flat surface to create a bottom so the mold will stand on its own.

2 REMOVE THE CLAY FROM THE OBJECT

Gently remove the clay from the object, being careful not to distort the shape.

3 CREATE MULTIPLE CASTINGS OF THE OBJECT

When removing the clay, if you find that there are low spots where the plaster could leak out, create a little clay dam to block those openings.

4 MIX THE PLASTER

Mix some plaster to about the same consistency of stiff egg whites. Fill the deepest parts of the mold with plaster.

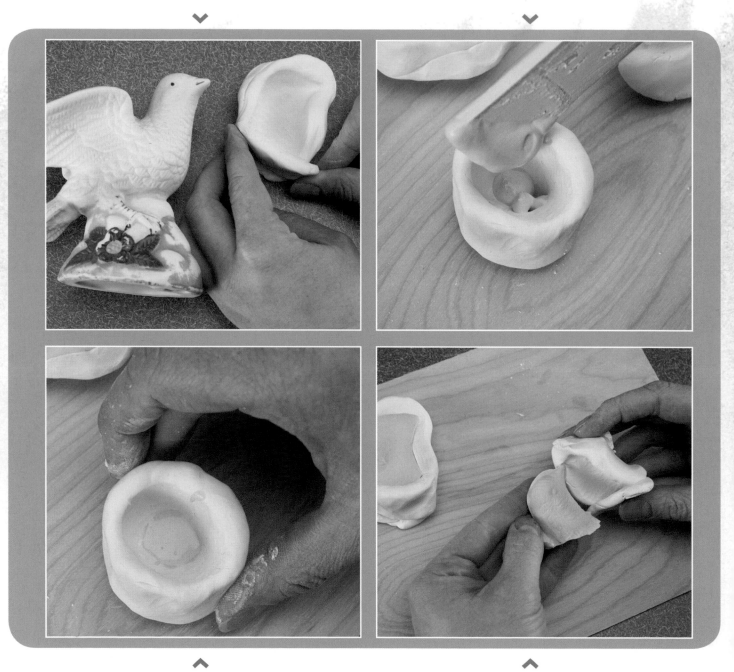

5 TAP TO REMOVE AIR BUBBLES

Gently tap the mold on the table to lift any air bubbles and to settle the plaster in the low spots.

6 CONTINUE TO FILL THE MOLDS WITH PLASTER

Tap as needed. Allow the plaster to set up thoroughly. Gently remove the castings from the clay.

7 SCRAPE THE EDGES OF THE MOLDS

Using a craft knife, gently scrape the edges of the castings to clean them up a bit.

8 PREPARE THE FRAME

Remove the glass from the frame. Reinsert the panel backing and turn the frame over. Tape around the perimeter so the plaster won't leak out. This will act as a box to contain the poured plaster that you will add later.

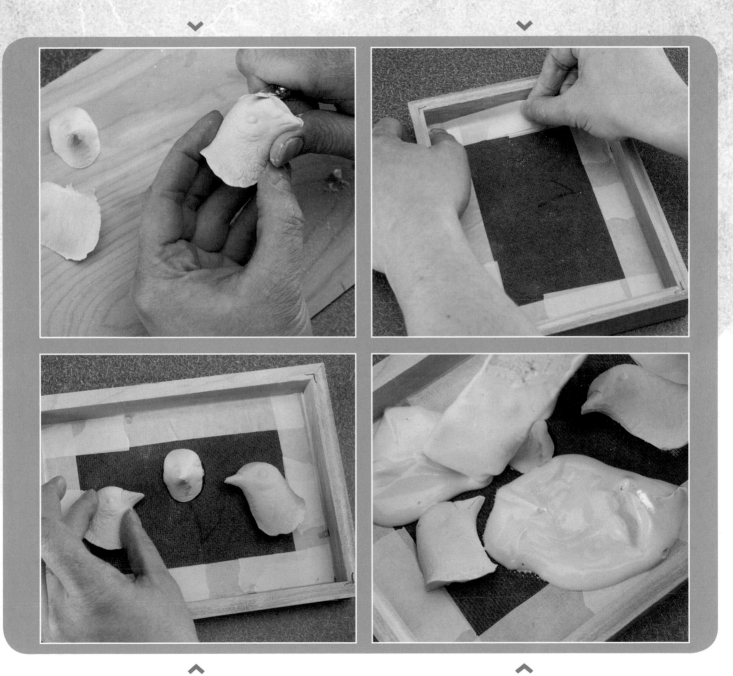

9 ARRANGE THE CASTINGS IN THE FRAME

Glue them down with the two-part epoxy. Let the glue cure thoroughly.

10 FILL THE FRAME WITH THE PLASTER

Mix some plaster and scoop it into the frame around the castings.

11 SETTLE THE PLASTER IN THE FRAME
Tap the frame on the table to release air bubbles and to settle the plaster evenly into the corners.

12 SMOOTH THE PLASTER AND THE SEAMS
If needed, use a small, wet paintbrush to touch up and blend the edges around the cast plaster pieces. Allow the plaster to dry.

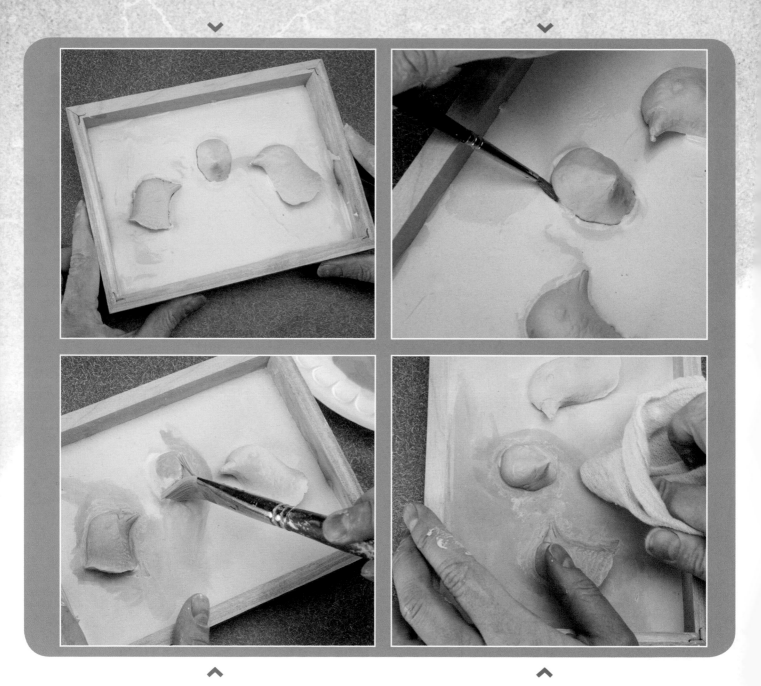

13 ADD A PAINT WASH
Using watered-down acrylic paint, add a wash over all the plaster, including the cast pieces.

14 BLEND THE PAINT WASH
Immediately wipe with a damp rag to even out and blend the paint.

15 PAINT THE CASTINGS
Using a small paintbrush, paint the castings a contrasting color, adding detail where desired. Let dry thoroughly.

16 ADD DETAILS TO THE CASTINGS AS DESIRED.
Apply a less watery wash of burnt umber paint and immediately wipe off with a damp rag, leaving some of the burnt umber paint in the low areas.

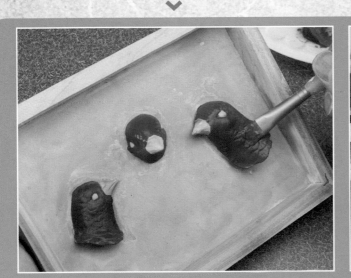

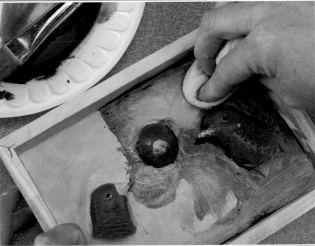

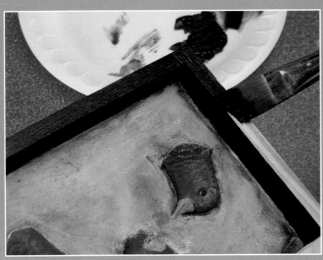

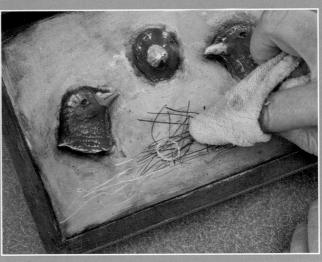

17 PAINT THE FRAME
I used more burnt umber, which contrasts nicely with the other colors I've chosen.

18 SCRATCH THE PLASTER TO CREATE INTEREST
Paint over the scratches and wipe off the excess with a damp rag, leaving paint in the crevices.

TIP
You could use a cradled wood art panel or wooden craft box instead of a frame.
In fact, anything that will contain the poured plaster will work great!

GIUSEPPINA "JOSIE" CIRINCIONE

Giuseppina "Josie" Cirincione is the author of three North Light Books: *Collage Lost and Found*, *Bent, Bound and Stitched* and *Solder Technique Studio*. Josie has been a contributor to several other books, and her work has been published in numerous Stampington publications. She teaches workshops across Arizona and sells her pieces in the greater Phoenix area. For updates and workshop information, visit **inkyblackpaperarts.com** or follow her on Facebook.

MARIE FRENCH

Marie French has taught art in schools and workshops, from preschoolers through adults. She has exhibited in galleries, museums and libraries across the United States. She has written for such publications as *Somerset Studio*, *Altered Couture*, *Belle Armoire*, *Haute Handbags*, *Everyday Jewelry* and *Cenizo Journal* for which she writes a column on desert wisdom, plants and folktales. You can read about Marie's healing and sacred art at **inspiritustudios.blogspot.com**.

TAMMY KUSHNIR

Tammy Kushnir is a mixed-media and digital artist whose works have appeared in various art shows and magazines such as *Somerset Studio* and *Somerset Memories*. Her designs can also be seen on iPods and cell phones via **www.decalskin.com** and sold through her Etsy store at **kush12.etsy.com**. Tammy is the author of *Wedding Journals and Keepsake Gifts* and *The Elemental Journal*.

STEPHANIE LEE

Stephanie Lee creates art in the studio of her Oregon home. She knows the power of creativity. She knows that the gift of being able to make art brings people back to the center of their innate creativity and helps them live more authentically in the world. She knows that for every creative inkling honored, there are countless dormant forces that awaken to support the effort. She loves learning for learning's sake and sharing what she knows with others as much as humanly possible. When she's not traveling to teach, she's experimenting with new ideas in metal and plaster smithing, writing, wrangling wild ponies—otherwise known as her two children—and digging in the garden soil. See what Stephanie is up to now—visit **stephanielee.typepad. com**.

ANNIE LOCKHART

Annie Lockhart is a self-taught, mixed-media assemblage artist… among other things! She has been gathering and collecting her "words" since she was a little girl in Texas. Annie loves exploring stories and recording memories from her layers of life, or of from those who came before. She has had the pleasure of teaching at artists retreats for the past several years with a focus on making heart and soul connections through the use of symbolism, memories and metaphors. She is the author of *Objects of Reflection: A Soulful Journey Through Assemblage*. She has also had her work and writings featured in several national magazines, and has been honored to sell her work at top juried art shows. Visit her website, **annielockhart. typepad.com**.

JEN OSBORN

Jen Osborn is a third-generation artist and writer and lives in rural Michigan. She creates artwork that's as fun to touch as it is to look at, and she has a knack for blending quirky vintage items with modern techniques. Jen is a lover of anything textured, crafting found objects into story quilts that tease your eyes and tickle your heart. She loves to stitch up a storm and create mixed-media collages. Jen is a jack-of-all-mediums and is currently teaching herself to paint, filling her art journals full of odd creatures and inspiring quotes. In addition to *Mixed and Stitched*, Jen also writes for numerous publications, including *Stitch Craft Create*. Visit with Jen at **themessynest.com**.

RUTH RAE

Ruth Rae is a classically trained jeweler who somehow found her true creative calling when she discovered a sewing machine. Best known for her mixed-media fabric work, Ruth teaches jewelry and fabric techniques extensively in the United States. Her art and articles have appeared in numerous publications and juried shows. Ruth's first book, *A Charming Exchange*, brought new ideas for collaborative jewelry. Her second book, *Layered, Tattered and Stitched: A Fabric Art Workshop*, will provide you with the inspiration and techniques to create fabric art with incredible depth and personal significance. Ruth has filmed two Quilting Arts instructional DVDs and has appeared on *Quilting Arts TV*. Ruth aspires to motivate others to follow their own artist inspirations with her art and musings. Learn more at **ruthrae.com**.

KELLY RAE ROBERTS

Kelly Rae Roberts is an artist, author and possibilitarian. She is the author of *Taking Flight: Inspiration & Techniques to Give Your Creative Spirit Wings*, a best-selling book featuring her insights on the creative life as well as her popular mixed-media techniques. She is also the author of *Flying Lessons: Tips & Tricks to Help Your Creative Biz Soar*, a popular e-book series. Her work has been featured in a variety of books and magazines, including *Where Women Create*, *Artful Blogging*, *Cloth Paper Scissors*, *Somerset Life*, *Somerset Studios*, *Memory Makers* and more. Much of her artwork is licensed and can be seen in stores nationwide on a variety of gift and home decor products. She currently lives in Portland, Oregon, with her outdoorsy husband John, her baby son True and their airplane-eared dog Bella. For updates and information, visit **kellyraeroberts.com**.

KRISTEN ROBINSON

After spending much of her life living in a suburb of a large city, Kristen and her family recently relocated to a much smaller city in southern Oregon. It is there that she has found an entire new world of inspiration and a much welcomed slower pace of life.

Following a career in the corporate world, Kristen soon found herself seeking a return to her roots (as well as her art degree). As her background was in fashion and art, she knew the two would marry and carry her ideas to light. With a renewed courage to pursue her true dream, Kristen set forth with paintbrush in hand. With a love of all things from the past and the stories locked within them, she is drawn to many different forms of art, from jewelry and textiles to painting and mixed media. It is her hope that her deep passion for writing, creating art and reading comes through in all things she creates.

As a Director's Circle Artist for *Somerset Studio* magazine, Bonne Vivante for *Somerset Life* magazine and a designer for ICE Resin, Kristen is truly doing what she loves to do. She now offers classes online through her blog, **kristenrobinson. typepad.com**, as well as at art retreats.

KIMBERLY SANTIAGO

A graduate from Austin Peay State University with a degree in Fine Art and a concentration in Graphic Design, Kimberly Santiago began her career as a graphic designer and was elated to be recognized in *HOW* magazine's self-promotion issue. She continued to work in the design field and win other awards, notably her Conquer Paper Promotional piece, which traveled to the Wiggins Teape's Paperpoint at Convent Gardens and Butler's Wharf in London, and continuing to a venue in Paris. From graphic design, she started teaching and later became a Department Chair of Graphic Design and Fine Art at O'More College of Design in Franklin, Tennessee.

Kimberly is the author of *Collage Playground* and a contributor to *Mixed-Media Paint Box*. She has written articles for *Somerset Studio Gallery* and *Cloth, Paper, Scissors*.

Kimberly currently works from her studio and art shop, Creative Corner at Hodgepodge in Clarksville, Tennessee. She blogs at **kimberlysantiagoart.blogspot. com**.

JENNIFER SWIFT

Jen Swift is a mother, artist and writer living in Plymouth, Minnesota. Aware that if she doesn't do something creative she'll go crazy, she tries to divide her time between those things she feels she must do and those she wants to do. Which is why she sews while waiting for carpool time, paints between loads of laundry and dreams up magazine articles in her head while grocery shopping. She is published regularly in Stampington magazines and volunteers with a local arts ministry, Art 2 Heart, designing products for an artisan group in Peru as well as other more local groups.

She loves to share her creative inspirations with others through her magazine articles and her book, *Creative Bloom: Projects and Inspiration in Fabric and Wire*. She also has a blog that she hopes inspires others to live their own creative lives in an everyday way, Art as Usual, that can be found at **blog. birdfromawire.com**.

SUSAN TUTTLE

Susan is the author of three North Light books, *Photo Craft: Creative Mixed Media and Digital Approaches to Transforming Your Photographs*, *Digital Expressions: Creating Digital Art with Adobe Photoshop Elements* and *Exhibition 36: Mixed-Media Demonstrations and Explorations*.

She is a photographer and an online digital art and photography instructor who resides in a small, rural town in Maine with her husband and two children. In addition to authoring her own books, Susan is a contributor in various North Light publications, including Jenny Doh's *Art Saves* and Liz Lamoreux's *Inner Excavation*. Her work has appeared in numerous Stampington publications, including *Somerset Studio*. Visit Susan's website, **SusanTuttlePhotography.com**, to learn more about Susan and her art and for great tips and advice on photography and more.

JANE ANN WYNN

Jane Ann Wynn is an artist whose work spans a broad spectrum of media, notably assemblage, jewelry, sculpture, drawing, painting and photography. Her work is characterized by the curious juxtaposition of found objects, utilizing vintage imagery and distressed treatments, suggestive of elegant decay and dignified decrepitude. Her overarching philosophy is that "Every object has a right to be heard." She frequently recycles found objects in unusual and often bizarre ways, for example, by creating an opulent pincushion from a doll's head.

In 2002, Jane established Wynn Studios, based in Maryland, along with her husband, Thomas Wynn. She teaches fine art in various community colleges in Baltimore County as well as Towson University. She maintains a constellation of Web presences, including **www.wynnstudio. com** and **janewynn.typepad.com**, and has appeared on television and Internet radio to illustrate her unique techniques. She has participated in dozens of exhibitions nationwide.

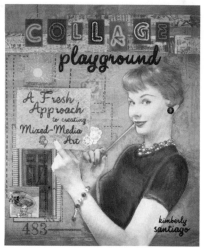

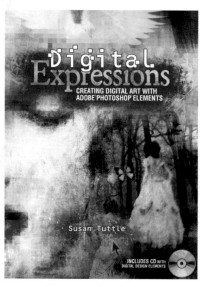

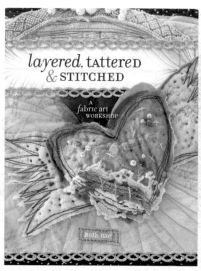

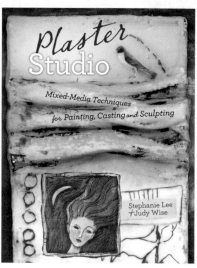

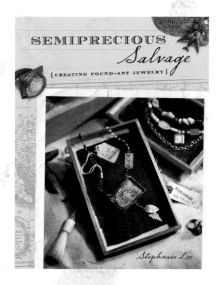

SEMIPRECIOUS
Salvage
[CREATING FOUND-ART JEWELRY]

Stephanie Lee

Solder TECHNIQUE Studio
SOLDERING IRON FUNDAMENTALS FOR
THE MIXED MEDIA ARTIST

GIUSEPPINA "Josie" CIRINCIONE

Taking *Flight*

INSPIRATION & TECHNIQUES
to give your
Creative spirit
wings

KELLY RAE ROBERTS

Tales of
ADORNMENT
Techniques for creating romantic resin jewelry

Kristen Robinson

the
elemental
journal

composing artful expressions
from items cast aside

Tammy Kushnir

*These and other fine North Light books are available at
your favorite local craft retailer, bookstore or online retailer,
or visit NorthLightShop.com.*

INDEX

A

aging. *See blackening solution; patina*
alphabet letters. *See collage words; letters; text*

B

backgrounds, 45, 93–95
banner, "Create," 36–43
beads, 17
 dangles, 39–43
 gemstone, 21–22
 wrapped, 43
beeswax. *See wax*
belt, leather, 29–30
Bird Nest Earrings, 8–12
Birdcage Memories, 64–69
Birdfeeder, 70–73
Bluebird of Happiness
 pincushion, 100–109
brass plate, 67
Broken Heart Necklace,
 24–27

C

Cast Object Assemblage,
 114–119
chain
 bronze, 21–23
 sterling, 26–27
charms
 bird, 18, 23
 dove, 39–42
Cirincione, Giuseppina
 "Josie," 84–85, 120
clay, for molding, 29,
 115–116
collage elements, 46–47, 78
collage words, 97. *See also
 letters; journaling; text*
Collaged Box, 48–53
color curves, adjusting,
 58–59
Contemplate Bird, 44–47
"Create" Banner, 36–43
crystals, 17, 53, 73
cuff, Guardian, 28–33

D

dangles, 20, 22, 39–43
découpage, 50
digital collage, 54–59
doves, plastic, 40

E

ear wires, 11–12
earrings, Bird Nest, 13–15
embellishments, 18, 112
encaustic, 78–79, 93, 97–99
ephemera, 37

F

faux felting, 103–104
feathering, 57, 59
felt, 37
files (digital), 56–59
foil wrapping, 89
frames, 117–119
French, Marie, 24–25, 120

G

glass cutting, 87–88
graphite, 96–97
Guardian cuff, 28–33

H

heat gun, 94, 98
highlights (digital files),
 56–57, 59
His Wings Necklace, 16–23
hue, adjusting, 58

I

imagery, 19, 44
images (digital), flattening,
 59

J

jewelry. *See also cuff, ear
 rings, necklaces, ring*
 healing, 25
 resin, 18–19
journaling, 67–69, 96
jump rings, 22

K

Kushnir, Tammy, 64–65,
 120

L

lasso tool, 57, 59
layering, 38–39, 46
 paper, 45, 61
 plaster gauze, 76–77
 stamping, 95
layers (digital), 54–59
Learning to Soar, 92–99
Lee, Stephanie, 8, 28,
 74–75, 114, 121

letters, 38, 61, 72. *See also
 collage words; journaling;
 text*
Lockhart, Annie, 80–81, 121

M

medal, miraculous, 25
mirrors, 47
mobiles, 81–83
My Fledgling, 54–59

N

necklaces
 Broken Heart, 24–27
 His Wings, 16–23

O

opacity, adjusting, 56–59
Osborn, Jen, 100–101, 121

P

paint
 acrylic, 32, 45, 47, 61, 66,
 77, 94–95, 99, 118–119
 craft, 37
 metallic, 50, 61, 73
 oil, 99
paper towel, paint-dyed, 37
papers
 decorative, 18, 51, 89
 layering, 45, 61
 selection of, 45
patina, 50, 72–73, 91
 blackening solution, 12, 15
pearls, 52, 72
 freshwater, 9–10, 14–15
photographs, 56–58
pincushion, Bluebird of
 Happiness, 100–109
plaster gauze, layering, 76–77
plaster of Paris, 29, 31, 114,
 116–118
Poetry Folio, 74–79

R

Rae, Ruth, 36, 121
resin, 18–19
resizing, 56, 59
ring, Bird Nest, 8–12
Roberts, Kelly Rae, 92–93,
 122
Robinson, Kristen, 16–17,
 122
rosary wrapping, 43
Royal Bird, 60–61

S

Santiago, Kimberly, 44, 60,
 122
shadows (digital files),
 56–57, 59
shoe clip, rhinestone, 27
soldering, 85, 90–91
Soul Shine, 80–83
stamping, 38–39, 42, 72,
 93–95
 into wax, 98
stitching, 38–39, 102–108
Swift, Jennifer, 110, 123
symbolism, of materials,
 25, 82

T

technical skills and tools, 59
text, 45, 61, 97. *See also
 collage words; journaling;
 text*
tinning, 90
turquoise heart, 25, 27
Tuttle, Susan, 54–55, 123
Tweet, 84–91
Two Birds on a Branch,
 110–113

W

wax, 78–79, 93, 97–99
white-washing, 50
wire
 annealed iron, 11, 111
 brass, 11, 73
 copper, 11, 14
 craft, 111
 galvanized, 66–67
 mixing types, 11
 silver, 9–15, 82
 steel, 111
wrapped beads, 43
wrapped dangles, 20
wrapped links, 20–21
Wynn, Jane Ann, 48,
 70–71, 123

17 16 15 14 13 5 4 3 2 1

Distributed in Canada by Fraser Direct
100 Armstrong Avenue
Georgetown, ON, Canada L7G 5S4
Tel: (905) 877-4411

Distributed in the U.K. and Europe by F&W MEDIA INTERNATIONAL
Brunel House LTD, Newton Abbot, Devon, TQ12 4PU, ENGLAND
Tel: (+44) 1626 323200, Fax: (+44) 1626 323319
Email: enquiries@fwmedia.com

Distributed in Australia by Capricorn Link
P.O. Box 704, S. Windsor NSW, 2756 Australia
Tel: (02) 4560-1600, Fax: (02) 4577-5288
Email: books@capricornlink.com.au

ISBN-13: 978-1-4403-2704-9

www.fwmedia.com

EDITED BY KRISTY CONLIN

DESIGNED BY KELLY O'DELL

PRODUCTION COORDINATED BY GREG NOCK

PHOTOGRAPHY BY RIC DELIANTONI, CHRISTINE POLOMSKY AND AL PARRISH

≫ METRIC CONVERSION CHART

to convert	to	multiply by
inches	centimeters	2.54
centimeters	inches	0.4
feet	centimeters	30.5
centimeters	feet	0.03
yards	meters	0.9
meters	yards	1.1

JOIN THE FLOCK: CHECK OUT CRAFTY BIRDS BONUS CONTENT!

Just can't get enough? We have a few tweet treats for you!
Have a smartphone with a QR code reader? Just scan the code to
the left for access to CRAFTY BIRDS bonuses, like free computer
wallpapers, quick links to contributor websites and more! Or visit
createmixedmedia.com/crafty-birds

THE BEST IN MIXED MEDIA—JUST FOR YOU!

Find the latest issues of
Cloth Paper Scissors magazine
on newsstands, or visit the website,
SHOP.CLOTHPAPERSCISSORS.COM.

These and other fine North Light mixed-media products are available at your
local art & crafts retailer, bookstore or online supplier.
Visit our website, CREATEMIXEDMEDIA.COM, for more information.

CREATEMIXEDMEDIA.COM: A GREAT COMMUNITY TO INSPIRE YOU EVERYDAY!

INSPIRATION AWAITS ...
CreateMixedMedia.com
LOOK. MAKE. MEET.

Connect with your favorite artists

Get the latest in mixed-media inspiration,
instruction, tips, techniques and events, and sign up
for our free newsletter

Be the first to get special deals on the products you
need to improve your mixed-media endeavors

 Follow CreateMixedMedia for the
latest news, free demos and giveaways!

 Follow us!
@CMixedMedia

 Follow us!
CreateMixedMedia